BIRKENHEAD
From Old Photographs

BIRKENHEAD
From Old Photographs

IAN COLLARD

AMBERLEY

Arms of the County Borough of Birkenhead.

First published 2011

Amberley Publishing
Cirencester Road, Chalford,
Stroud, Gloucestershire, GL6 8PE

www.amberley-books.com

British Library Cataloguing in Publication Data.
A catalogue record for this book is available from the British Library.

ISBN 978 1 84868 579 6

Typeset in 10pt on 12pt Sabon.
Typesetting and Origination by Amberley Publishing.
Printed in the UK.

Introduction

A Benedictine priory was established on the Wirral Peninsula in 1150 on a headland of birch trees, when Hamon de Mascy granted lands to the Order of St Benedict. A number of Black Monks moved from Chester, becoming the first inhabitants of Birkenhead, which was described as the little headland of the birches. The monks took advantage of the natural resources of the peninsula, which is surrounded by water with a river rich in fish.

The Benedictine monks were renowned for their hospitality to travellers and the priory was built next to a landing stage at the river near Woodside. However, by 1284 the road was diverted away from the ferry, as the priory could not cope with the demands made on it by travellers, and a petition was sent to Edward II informing him that they were burdened beyond their resources.

Houses were built to accommodate the travellers in 1318, and in the charter of 1330, Edward III granted the Prior and Priory of Birkenhead and their successors forever the passage over the arm of the sea and the right to make reasonable charges. Following the dissolution of the monasteries in 1536, the monks were forced to leave the priory and their lands were confiscated by the King and sold to Ralph Worsley, who became lord of the manor. The Chapter House was used as a church and the accommodation buildings were converted to dwellings.

There were various disputes in the sixteenth and seventeenth centuries between the burgesses of Liverpool and the Powell family, who were the owners of the Woodside ferry. However, when the Powell family died out, the estates were sold in 1694 to Alderman John Cleveland, and a boathouse and quay were built at Woodside landing stage. Ownership of the land passed to the Price family in 1716 and they leased the Woodside Ferry to a succession of tenants.

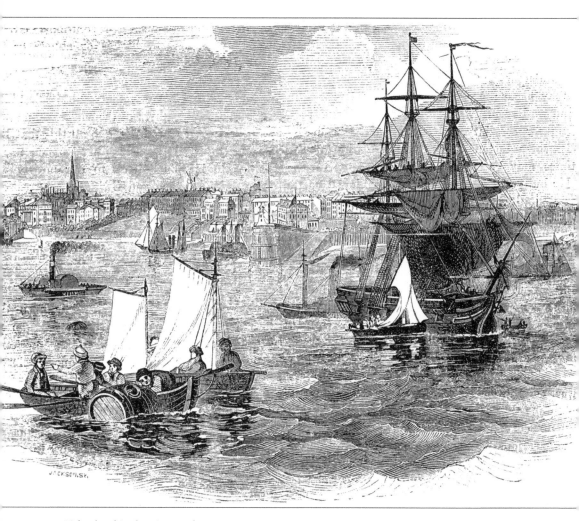

Birkenhead in the nineteenth century.

In 1815 Francis Richard Price sold land fronting onto the river, and the area was developed with the construction of new houses. The number of passengers travelling on the ferry increased and a paddle steamer was placed on the service from Woodside to Liverpool. The chapter house and priory buildings were replaced by a new church. The foundation stone was laid in July 1819, and it was dedicated to St Mary and consecrated on 17 December 1821.

The population continued to increase in this period, and in 1817 a new half-hourly ferry service from Tranmere to Queen's Dock in south Liverpool was inaugurated and a steam ferry was later introduced on the Woodside service. The new services from Liverpool to the Wirral

encouraged people and merchants to move to Birkenhead, and the population of 200 in 1821 doubled in the following two years.

In 1810 William Laird moved to Liverpool to help attract orders for his father's rope works in Greenock and soon became a director of two shipping companies. He also set up an agency for James Watt's steam engine and purchased a sugar house. He was initially interested in a scheme to sail ships up the River Dee and cross the peninsula by canal to Birkenhead. With this in mind, he purchased land and a survey carried out by Telford, Nimmo and Stevenson, civil engineers, in 1828 came to the conclusion that a two-lane canal would cost approximately £1,401,000 and £734,000 for a single-lane waterway. Liverpool Council, merchants and businessmen soon became alarmed at the prospect of this local competition and they purchased large areas of land and the scheme was abandoned.

However, Laird bought land near Wallasey Pool at Vittoria Wharf and built a boiler house which later became the Birkenhead Iron Works. The Great Western Railway and the London & North Western Railway were interested in gaining access to the Mersey

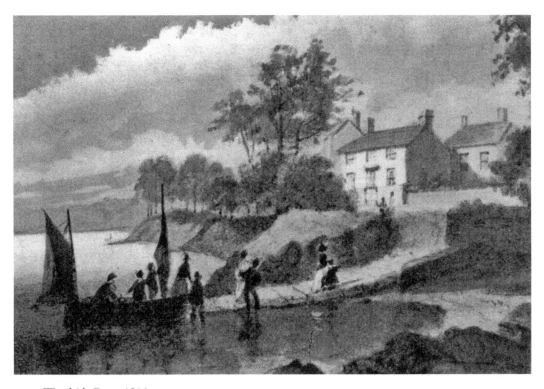

Woodside Ferry, 1814.

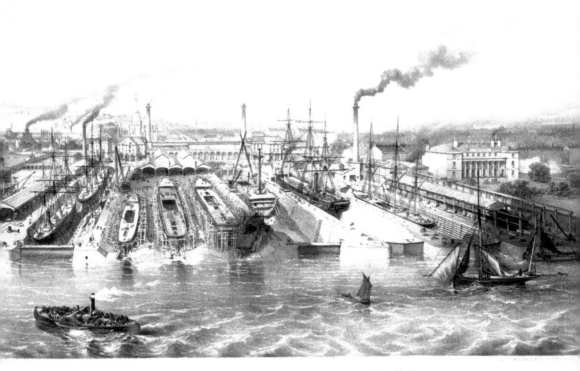

BIRKENHEAD IRON WORKS.
GRAVING DOCKS AND SHIP BUILDING SLIPS.
ENGINEERING & BOILER MAKING SHOPS.
JOHN LAIRD ESQ? PROPRIETOR.

The Birkenhead shipyard in the 1850s.

docks, and when Sir John Tobin and John Askew purchased land, they asked Thomas Telford to look at the possibility of building a port on the Wirral side of the river.

Gillespie Graham, an Edinburgh architect, was appointed by William Laird in 1826 to design and build Hamilton Square and the roads and buildings at the centre of the town. Laird named Hamilton Square after an ancestor who became an Archbishop of Scotland. Laird also had a house built in Cathcart Street. The census of 1831 showed a population of 2,569 inhabitants in Birkenhead, and two years later an Act of Parliament was approved for 'paving, lighting, watching, cleansing and otherwise improving the Township of Birkenhead, and for regulating the Police and the establishment of a Market'. The Improvement Commissioners were established to raise

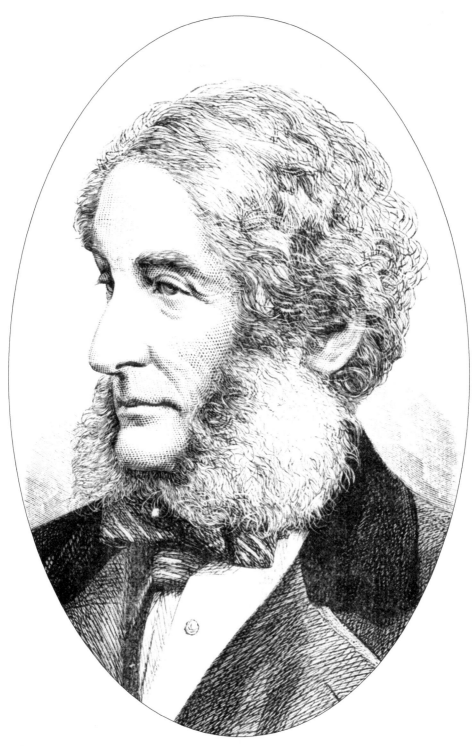

John Laird.

£8,000 in rates and tolls. At their first meeting on 25 June 1833, they discussed plans to appoint police and firemen, purchase fire engines and to build a market.

William Laird's son, John, who was a trained solicitor, joined his company in 1828. In the 1830s they made the decision to build ships of iron not wood, and in 1837 they invited Professor Airey, the Astronomer Royal, to carry out tests on board their latest ship, the *Rainbow*. Airey concluded that the mass of iron on an iron vessel took the compass off course, but that it was possible to make allowances to correct the readings. The *Rainbow* was the largest ever iron ship and was handed over to her owners by Laird in 1837. In 1840 the first iron-built ship for the British Government was constructed. It was a 113-foot packet named *Dover* and was followed by an order for four gunboats for the Royal Navy; John Laird also decided to build a frigate that was propelled by paddle wheels.

In 1835 the Woodside Ferry Company was formed to build a railway from Chester to Woodside, but this plan was opposed by the Birkenhead & Monks Ferry Company and several landowners who later formed the Birkenhead & Chester Railway Company. The two schemes were discussed by the arbitration panel in Parliament and work on the Chester & Birkenhead Railway was started in 1838, with a single line opened in September 1840. The Company purchased most of the shares of the Woodside Ferry Company and acquired the Monks Ferry Company for £25,000 in 1840.

The Improvement Commissioners took over responsibility for the Woodside ferry in 1842, and the following year they drew up plans to build a dock system at Birkenhead which received Royal Assent in Parliament in 1844. The foundation stone was laid by Sir Philip Egerton, Member of Parliament for Cheshire, on 23 October 1844, on the same day that Monks Ferry Station was opened, giving rail passengers a direct link with Liverpool. Egerton and Morpeth Docks were opened by the Dock Commissioners on 5 April 1847, followed by the Great Float, which was later divided into East and West Floats. Following complaints about the high costs of shipping goods through the Port of Liverpool, a Royal Commission was appointed which recommended setting up a new body to be responsible for running the docks. On 1 January 1858 the Mersey Docks and Harbour Board took over the operation of the docks at Liverpool and Birkenhead,

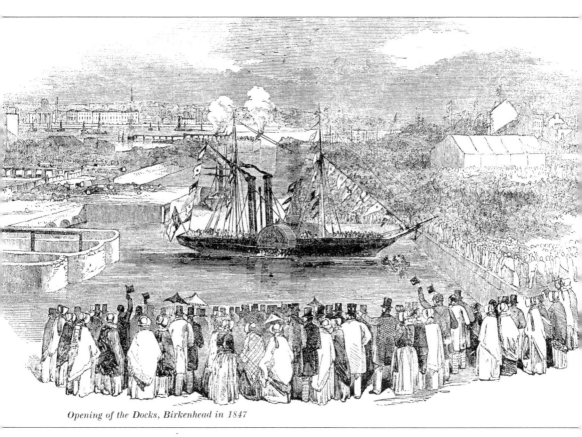

Opening of the Docks, Birkenhead in 1847

Opening of Birkenhead Docks in 1847.

controlled by twenty-eight Dock Trustees; John Laird was appointed as a nominee of the government.

Birkenhead Park was designed by Joseph Paxton and was opened on 5 April 1847. Birkenhead was the first town to ask Parliament for the powers to build a park, and the opening was attended by over 10,000 people. The American landscape architect Frederick Law Olmsted visited the park in 1850 and it influenced his design for Central Park in New York. He described Birkenhead as 'a model town' and one which was built 'all in accordance with the advanced science, taste, and enterprising spirit that are supposed to distinguish the nineteenth century'.

The Birkenhead Street Tramway was established in 1860. It operated from Woodside Ferry to Birkenhead Park and was the first street tramway to operate in Europe. The Birkenhead Gas and Water Company was purchased by the Improvement Commissioners

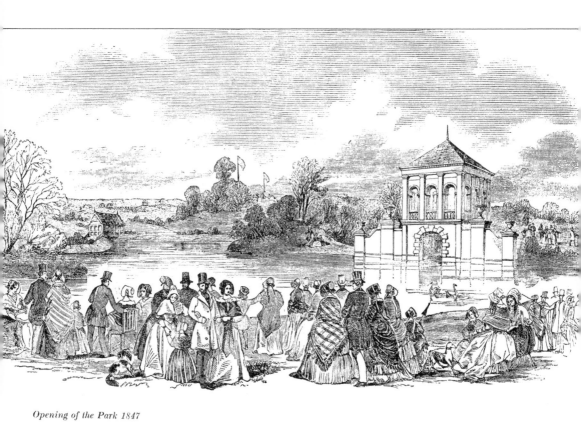

Opening of the Park 1847

Opening of Birkenhead Park on 5 April 1847.

in 1859 and Birkenhead, Oxton, Tranmere and Higher Bebington became a Parliamentary Borough in 1861. A petition requesting a Charter of Incorporation was granted on 13 August 1877, and the Great Seal was affixed to the Charter which was granted to the Mayor, Aldermen and the Burgesses of the Borough. The Parliamentary constituency covered an area of 3,850 acres and the first election for the new council took place on 14 November 1877, creating fourteen Aldermen and forty-two councillors. By 1878 the population of the Borough was 77,260, and under the Local Government Act of 1888 the town was created a County Borough – the population had increased to 99,000. The borough included the parish of Birkenhead St Mary and the townships of Bidston, Claughton with Grange, Oxton, Tranmere and part of Bebington, later known as Rock Ferry. Landican, Prenton and Thingwall were included in 1928, followed by Noctorum, Upton and Woodchurch in 1933.

Parliamentary authority was obtained in 1871 for the construction of a double-track railway to link Liverpool to the Wirral, but it took nine further years for funds to be obtained to start the project. The original contractor soon got into financial difficulties and the job was given to Major Samuel Isaac, who had made a fortune from work during the Crimean War. The boring machine was devised by Colonel Beaumont of the Royal Engineers, and explosives and picks and shovels were used for the building of the main tunnel. The Prince of Wales opened the line from James Street in Liverpool to Hamilton Square in 1886, and the track was extended to Birkenhead Park, West Kirby and New Brighton in 1888 and Rock Ferry in 1891. The following year an underground station was opened at Central Station in Liverpool. The trains were initially propelled by steam engines but the system was electrified in 1903, becoming the world's first electric railway.

The station at Monks Ferry was closed in 1878 and the passenger services transferred to Woodside Station. A new line was opened from Hoylake to the Dock Station at the Great Float which complemented the Hooton to West Kirby Line. The Wrexham, Mold & Connahs Quay Railway linked with the Manchester, Sheffield & Lincolnshire Railway in 1896, providing a link from the main line to Bidston. Lever's soap, animal feed and margarine works at Port Sunlight and Price's Chemicals used coal, and there was a full train every day from Wigan to Port Sunlight. In 1886 there was 1,800,000 tons of coal exported from Birkenhead.

Mrs W. H. Lever performed the ceremony of cutting the first sod at Port Sunlight on 3 March 1888, following the decision to move production of 'Sunlight' soap from Warrington. Lever Brothers was founded by William Hesketh Lever, and by 1884 a decision was made to specialise in the manufacture and marketing of soap. He leased a factory at Warrington in 1886 and went into partnership with his brother, James Darcy Lever.

Port Sunlight had been chosen as it allowed room for future expansion and was close to a pool of labour. It was also ideally placed, with its road, rail and water links. The first factory was opened in 1889, followed by the construction of the first cottages two years later, and the original village was completed by 1897. At the International Housing Conference at Port Sunlight in 1907,

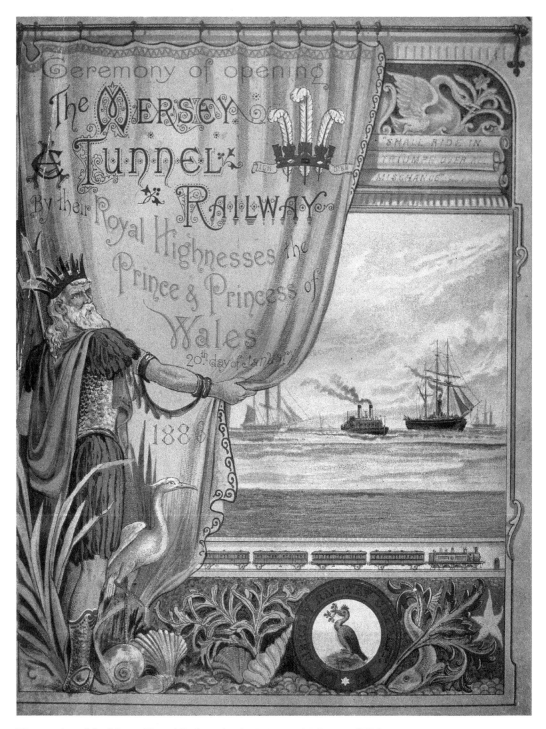

The opening of the Mersey Tunnel Railway by the Prince and Princess of Wales.

Lever stated, 'The building of ten to twelve houses to the acre is the maximum that ought to be allowed. Houses should be built a minimum of 15 feet from the roadway and every house should have space available in the rear for a vegetable garden. Open spaces for recreation should be laid out at frequent and convenient centres. A home requires a greensward and garden in front of it, just as much as a cup requires a saucer.'

Lever was created a baronet in 1911 and a baron in 1917, taking the maiden name of his late wife, Elizabeth Hulme, to form the title Leverhulme. Elizabeth died in 1913 as Lady Lever, but never Lady Leverhulme. In 1922 he was raised in the peerage to the rank of viscount.

Lever had completed 890 houses at Port Sunlight at the time of his death in 1925 and was responsible for the construction and provision of a number of important community buildings. Gladstone Hall, Hulme Hall, the Bridge Inn, the Gymnasium, Open-Air Swimming Bath, the Girls' Club and Cottage Hospital and other community-based facilities were provided for the use of people living in the village. Christ Church was built and the Lady Lever Art Gallery was completed in 1922. It was opened by Princess Beatrice, and the Prince of Wales (later King Edward VIII) visited in 1931; the Duke of York (later King George VI) opened a group of cottages which bear his name in 1934.

The Company merged with the Dutch company Margarine Unie in 1930 to form Unilever, and Port Sunlight was placed under the management of Unilever Merseyside Limited in 1960, becoming UML Limited in 1968. The village was declared a Conservation Area in 1978, and in 1980 the houses became available for the tenants to purchase.

The Foreign Animals Wharves were established at Wallasey and Woodside in 1878 and came to handle half a million animals a year. Cattle were shipped onwards or were slaughtered at the lairage and chilled meat was sent from the wharf. Most of the cattle arrived from the Republic of Ireland at Woodside or Wallasey Stage and were brought up bridges to the lairage, which had an area of 98,000 square yards and could handle 6,000 cattle and 12,000 sheep at any one time. Grain was imported to Birkenhead Docks from European and Black Sea ports and, later, North and South America, India and

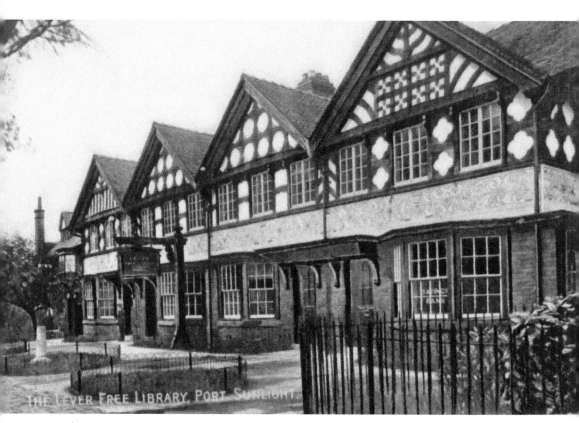

The Lever Free Library at Port Sunlight.

Baltic ports. Chemicals and minerals were imported and factories set up around the dock estate to manufacture copper, steel, chemicals, cement, fertiliser, oils and bricks. Iron ore was imported through Birkenhead for onward shipment to steelworks in North Wales; special cranes and handling equipment were provided at Bidston Dock, and by 1954 the iron ore trade had increased to one million tons. By 1956 it doubled to two million tons a year.

The Queensway road tunnel, linking Birkenhead with Liverpool, was completed in 1934. In the 1920s it became clear that the vehicular ferries operating across the river were having difficulties in coping with the level of traffic. A Parliamentary bill was passed and Edmund Nuttall was appointed as the main contractor. By 1928 the two pilot tunnels met, and on completion of the project the tunnel was opened by King George V on 18 July 1934. By the early 1960s traffic had increased and plans were drawn up for the construction of another tunnel between Liverpool and Wallasey. Work began

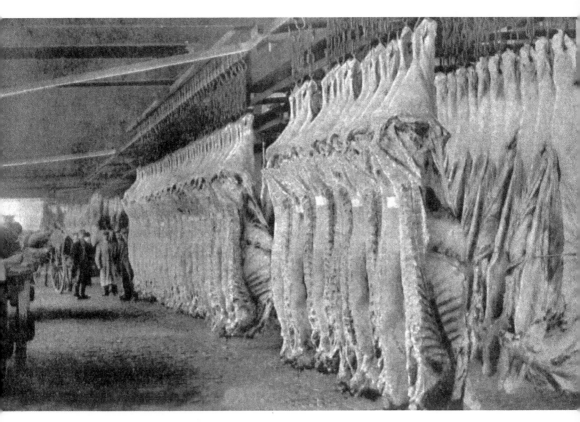

The lairage at Birkenhead.

in 1966, and the first tube of the new tunnel was opened by Her Majesty The Queen on 24 June 1971.

The Tranmere Oil Terminal was opened in 1960 to cater for the growing oil trade through the Port of Liverpool. The crude oil discharged at Tranmere is transferred through a 15-mile pipeline to Stanlow in Cheshire, which is part of the Shell Manufacturing Complex situated at Ellesmere Port in Cheshire.

The Local Government Act 1972 created the Metropolitan Borough of Wirral, in the metropolitan county of Merseyside by merging Birkenhead with Wallasey, the municipal borough of Bebington and the urban district of Hoylake. It contains the Parliamentary constituencies of Birkenhead, Wallasey, Wirral South and Wirral West.

Following the opening of the new Royal Seaforth Dock in 1970, many of the items shipped through Birkenhead Docks were transferred to the new facilities in Liverpool, where specialist container, meat- and grain-handling terminals were built, and

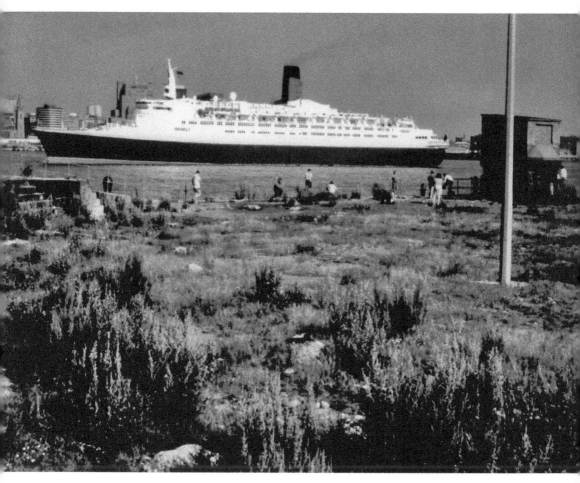

The site of the Twelve Quays development taken on the occasion of the first visit of the *Queen Elizabeth 2* to the Mersey on 24 July 1990.

there are now only a few operational berths at Birkenhead Docks. However, a new roll-on/roll-off terminal was built in the river near Morpeth Dock, providing facilities for passengers and cargo services between the port and Belfast, Dublin and Douglas, Isle of Man.

The Mersey Docks & Harbour Company was acquired on 22 September 2005 by Peel Ports, who stated that they were committed to giving priority towards the redevelopment and regeneration of the Liverpool and Birkenhead Dock Estate. Consequently, in September 2006 they announced plans for possibly the largest regeneration scheme in the country. It was called Wirral Waters and would see the transformation of Birkenhead, costing around £4.5 billion. It will cover an area of 18 million square feet and will create a

world-class mixed-use waterfront development, providing major benefits for the local economy by creating tens of thousands of new jobs and bringing inward investment to Birkenhead and Wallasey.

A new retail and leisure quarter will be developed, incorporating green measures such as cycle and pedestrian routes. The East Float and Vittoria Dock will form the main section of the new buildings and skyscrapers, and these will be linked by pedestrian bridges to retail and leisure developments, cafés, bars and restaurants.

It is envisaged that new residential apartments will provide over 15,000 homes in a district with the potential of a population of over 25,000 people. The plans allow for 5 million square feet of office space, with most having views over the Wirral Peninsula, the River Dee and the Liverpool Waterfront. Areas have been divided into quarters, with the 'Retail and Leisure Quarter' located adjacent to Bidston Moss and the 'Mixed Use Quarter' located at East Float and Vittoria Dock; the total floor area of these Quarters will be 1,625,000 square metres. The dock system at Birkenhead will continue to operate around this development, as the West Float will provide maritime and port-related industry and work. If this multi-million-pound investment does come to fruition, it will halt the decline in decay of the area and bring much-needed jobs and investment to the people of Birkenhead.

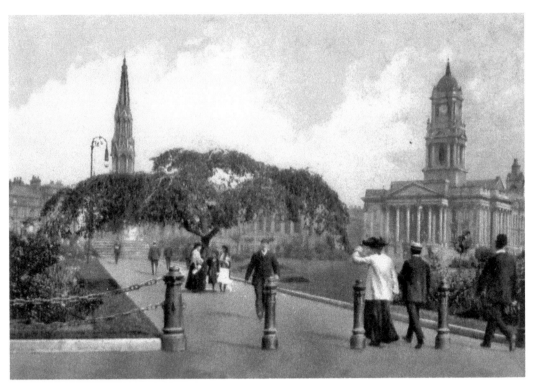

Hamilton Square and Birkenhead Town Hall.

A postcard from Birkenhead.

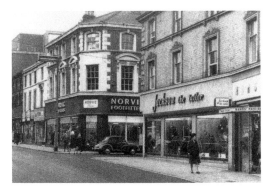

L. ELLIS
FURNISHING

NEW LARGE SHOWROOM

Contract. Ship's and Domestic Furnishers

Established Over One Hundred Years

ESTIMATES	ALBION WORKS	ALBION STREET
WITHOUT	BIRKENHEAD	
OBLIGATION		Telephone:- 051-647 6916

Above left: Grange Road, Birkenhead, *c.* 1960.

Above right: L. Ellis was founded in 1857 and, after developing from a dye-works through a laundry, was engaged in all aspects of furnishing. The domestic side of the business was conducted from the showroom in Heswall trading under the name 'Michael Ellis Furnishing', while contract furnishing and other activities were carried out at Albion works alongside the Town Hall at Birkenhead where the company was located. The Albion works contained a showroom, workshops, stores and administration offices where advice was given to customers in the choice of carpets, carpet tiles, vinyl tiles, linoleum, fabrics for upholstery, loose covers, curtains and wall coverings. The items were made into finished products at the works and a service was provided to fit the products in the customer's home. The company also provided new and replacement furniture aboard ships from liners and tankers to cargo vessels and coasters. They also provided linens, bedding and disposable paper products.

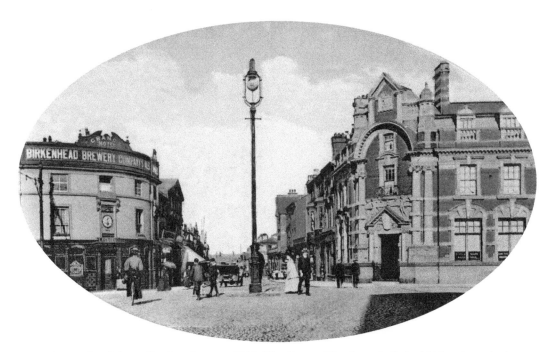

Grange Road from Charing Cross, *c.* 1910. The Grange Hotel was built in 1840 and survived until 1982. Martins Bank, later Midland Bank, was built in 1901 and has now been converted into a bar.

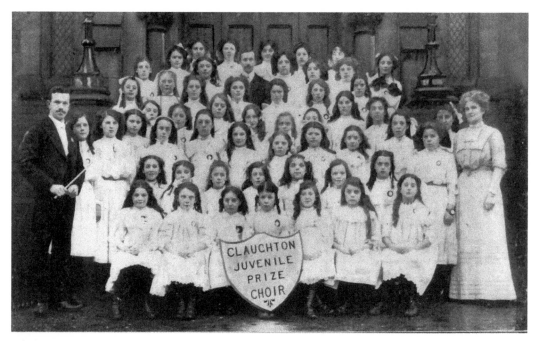

The Claughton Juvenile Prize Choir, first-prize winners in the Liverpool, Birkenhead, Corwen and New Brighton music festivals.

Victoria Park, Birkenhead. The Towers, the French-style chateau, was built by Victor Poutz in the 1860s. The estate was purchased by Birkenhead Corporation and opened to the public in 1901. It housed refugees in both world wars, and was then converted into apartments and finally demolished in 1965.

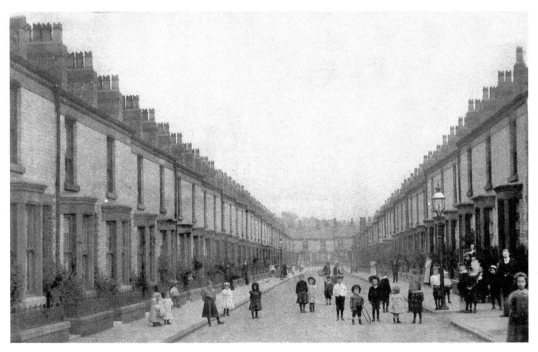

Moorland Road, Tranmere.

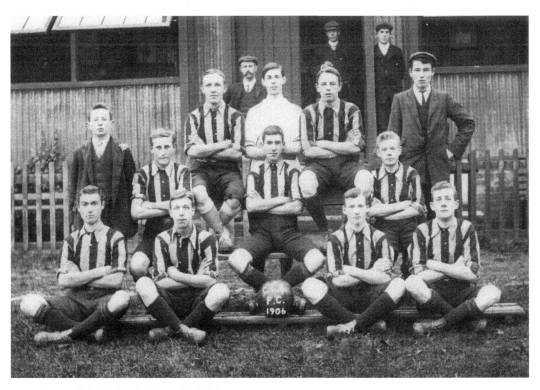

Cammell Laird football team in 1906.

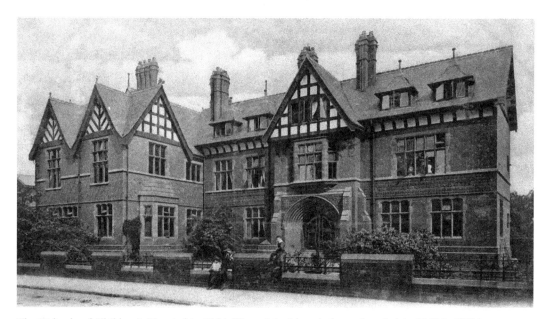

The Birkenhead Children's Hospital in 1904. The original hospital was founded in 1869 in Wilkinson Street, and was known as the Wirral Sick Children's Hospital and Dispensary. The hospital moved to Grovefield Villa in Oxton Road in 1872, and the new hospital in Woodchurch Road was opened by the Duke of Westminster in 1883 and an extension was added in 1903. It closed when the new Arrowe Park Hospital was opened in 1982.

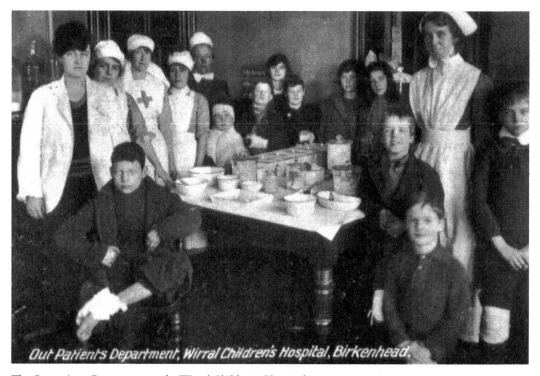

Out Patients Department, Wirral Children's Hospital, Birkenhead.

The Outpatients Department at the Wirral Children's Hospital.

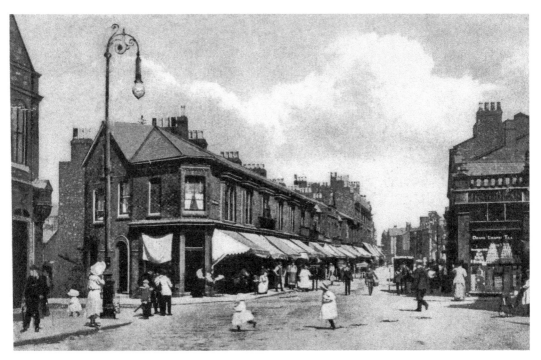

Grange Road West, Birkenhead.

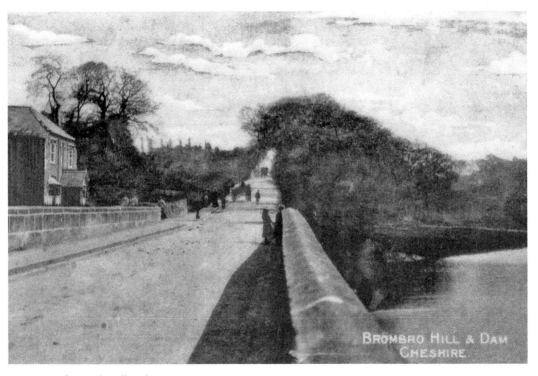

Bromborough Hill and Dam.

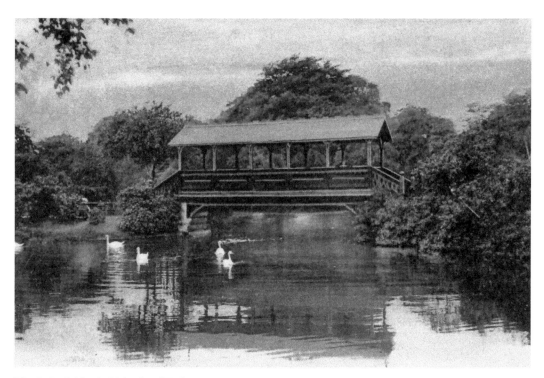

The Swiss Bridge in Birkenhead Park.

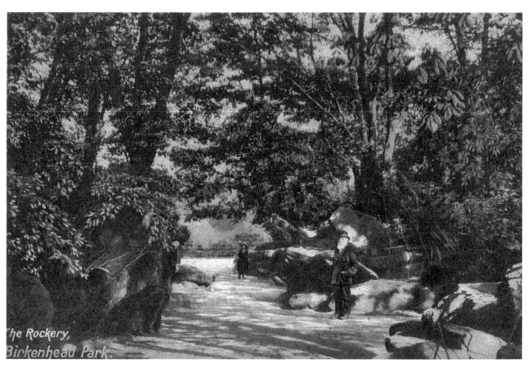

The Rockery in Birkenhead Park.

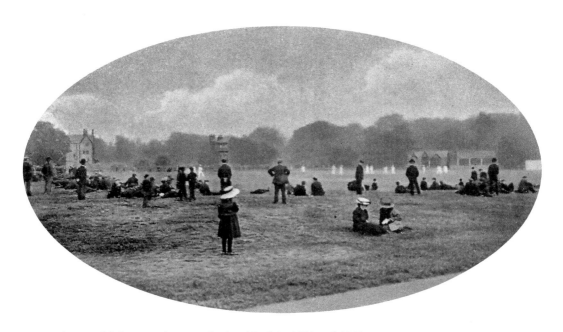

Above and below: Cricket in Birkenhead Park in 1909 and 1960.

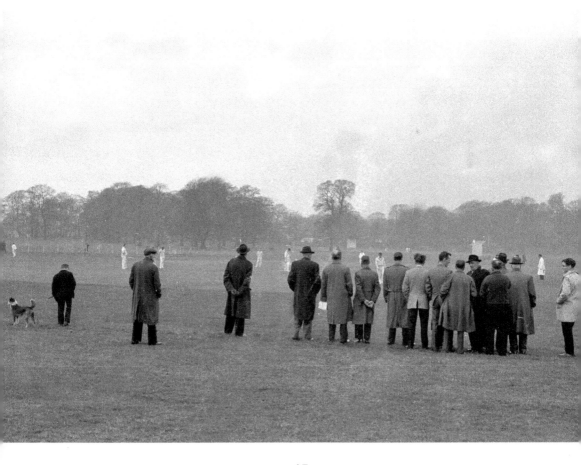

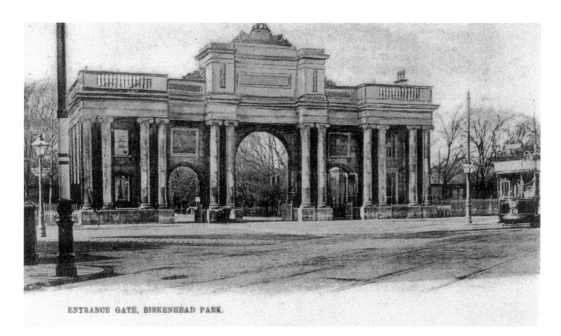

ENTRANCE GATE, BIRKENHEAD PARK.

The Entrance Gate in Birkenhead Park was designed by Lewis Hornblower and is on the junction where Park Road North meets Park Road East. The frontage measures 125 feet, with a central carriageway through an arch of 18 feet span which is 43 feet in height. The original gates featured the armorial bearings of Birkenhead Priory.

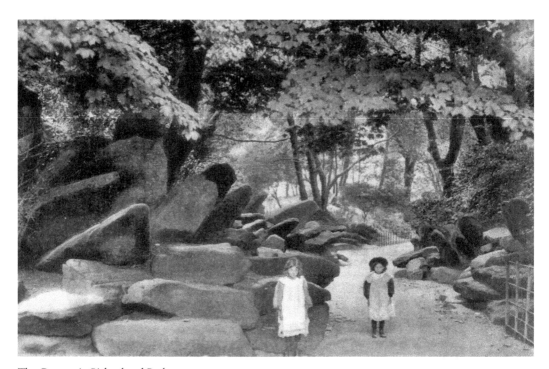

The Grottos in Birkenhead Park.

Liverpool and Birkenhead

stand at the import and export gateway to the great industrial regions of England.

Martins Bank, with its Head Office in Liverpool, offices in London, and a network of nearly 600 branches covering the important provincial cities and towns of England and Wales, is organised to assist industrial and commercial enterprises great and small.

MARTINS BANK

Martins Bank advertisement.

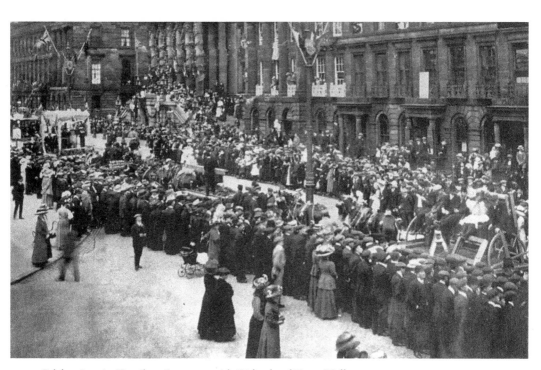

Celebrations in Hamilton Square outside Birkenhead Town Hall.

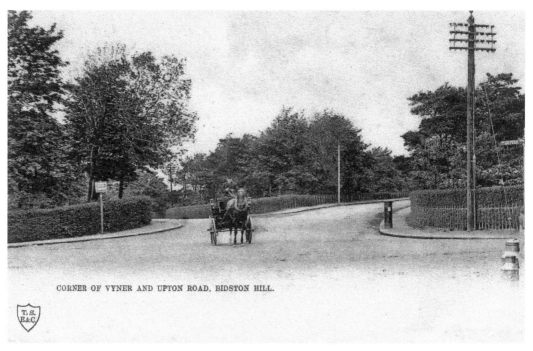

Corner of Vyner Road and Upton Road on Bidston Hill.

St Aidan's College, Birkenhead. The college was founded in 1846 by the Reverend Joseph Baylee to prepare men for the ministry of the Church of England. The college was situated between Shrewsbury Road and Forest Road and was demolished in 1969; a housing development has since been built on the site.

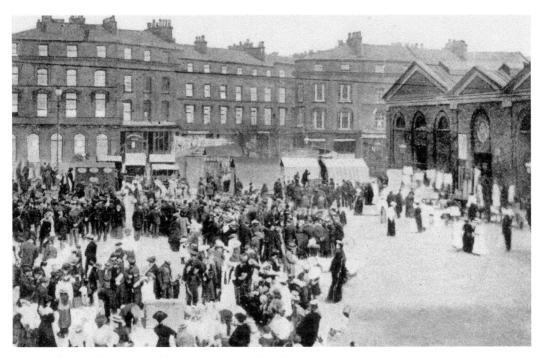

Stalls outside Birkenhead Market on a Saturday afternoon.

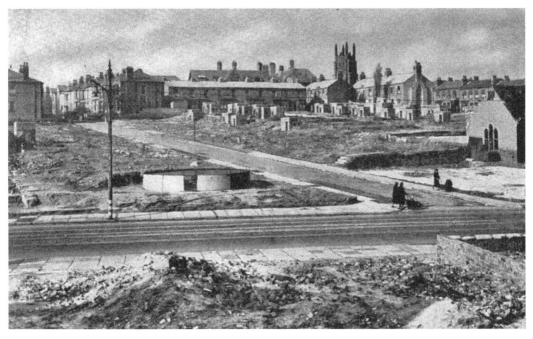

Damage around Borough Road after air raids and bombing on 8 May 1941. The Children's Hospital and Congregational church in Oxton Road can be seen in the centre of the photograph.

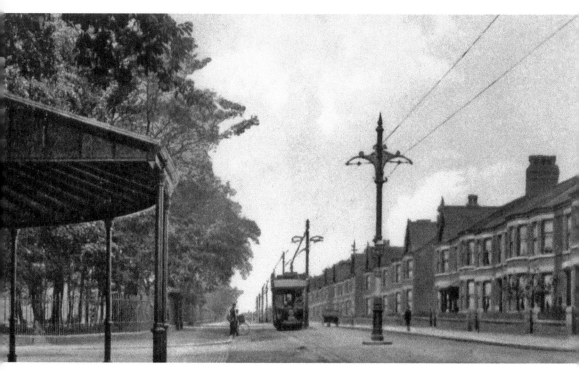

Park Road North in 1909.

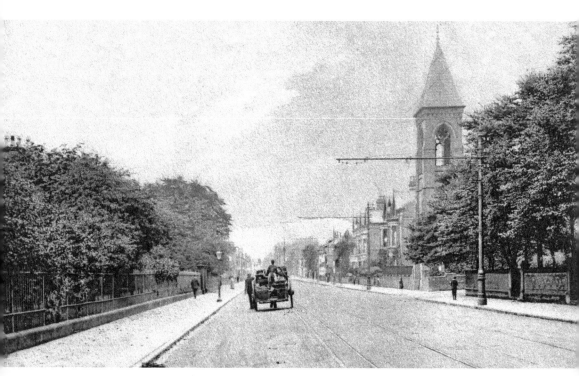

Park Road South in 1907.

Above left: W. Marchbank & Company Limited were established in Livingston Street, Birkenhead, around 1920. Maps of Birkenhead dated 1858 shows that there was a sawmill and timber yard on the site. The firm initially catered for the shipping industry and local customers, but between the wars they diversified, particularly in regard to the building and joinery trades, and a reputation was made for high-quality timber and sawmilling. A Treatim plant was installed which helps treat and preserve timber from dry rot and woodworm.

Above right: Storeton Engineering Service Company undertook vehicle servicing and body repairs, panel beating, resprays, insurance repairs, engine tuning, wheel balancing, wheel alignment, batteries, tyres and spares.

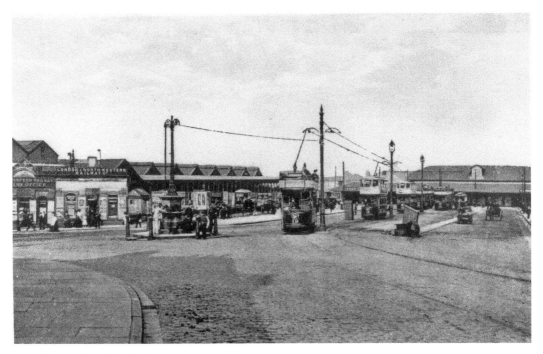

Approach to Woodside Ferry.

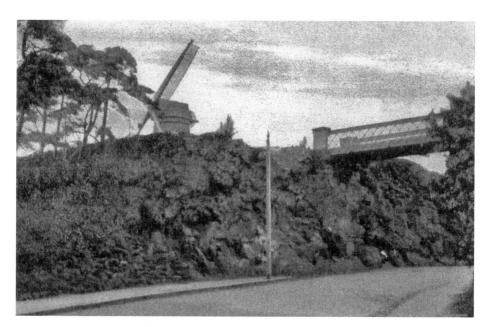

Vyner Road, Bidston, *c.* 1906.

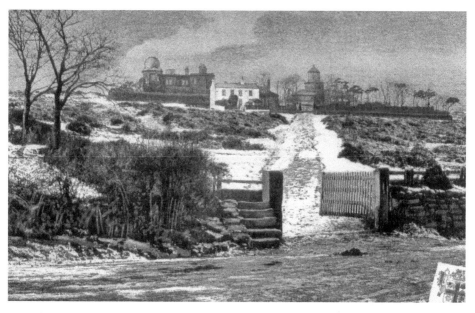

Bidston Hill and Observatory in 1907. The Bidston Observatory was the home of the Institute of Coastal Oceanography and Tides, which was founded in 1843. The observatory was transferred to the site in Bidston in 1864, where astronomical and meteorological observations were continued under the aegis of the newly formed Mersey Docks & Harbour Board. Tidal predictions were prepared at Bidston for more than half the major ports in the world and work was carried out on tidal streams, non-tidal currents, surface waves and other processes of tidal circulation and mixing. However, the Institute moved from the site at Bidston to Liverpool University in 2003 and the Grade II-listed building was advertised for sale.

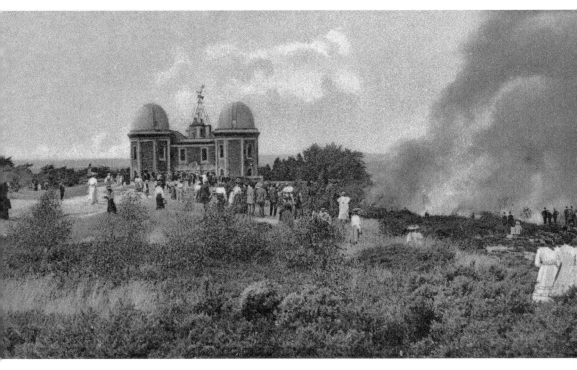

A bush fire on Bidston Hill in 1906.

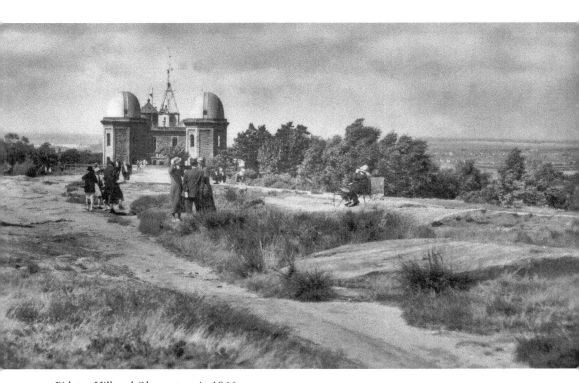

Bidston Hill and Observatory in 1966.

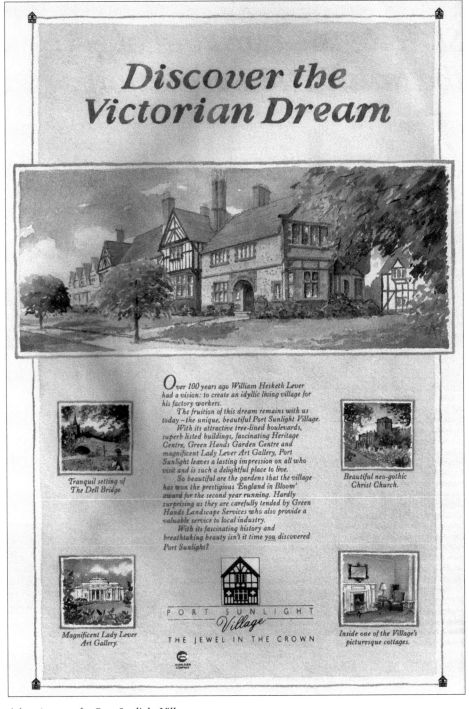

Advertisement for Port Sunlight Village.

Port Sunlight Village.

Hulme Hall, Port Sunlight.

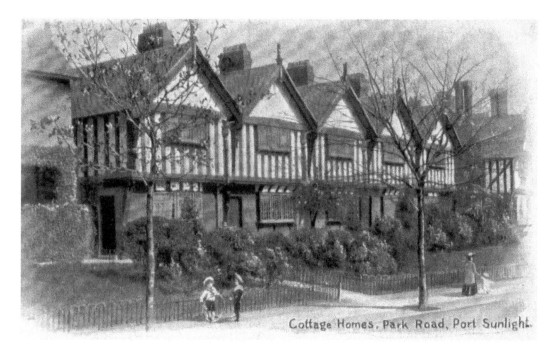

Park Road, Port Sunlight.

Greendale Road, Port Sunlight.

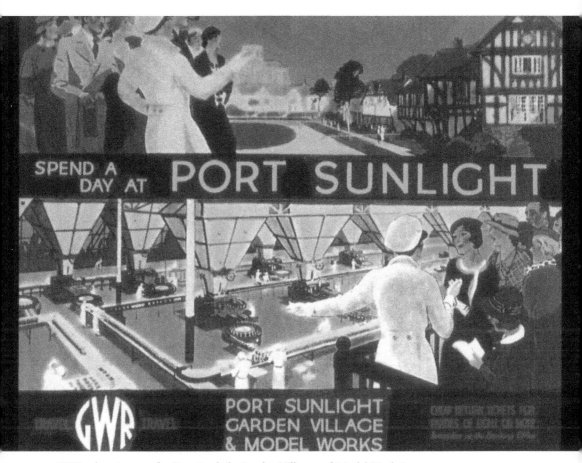

GWR advertisement for 'Port Sunlight Garden Village and Model Works'.

Birkenhead Central Station.

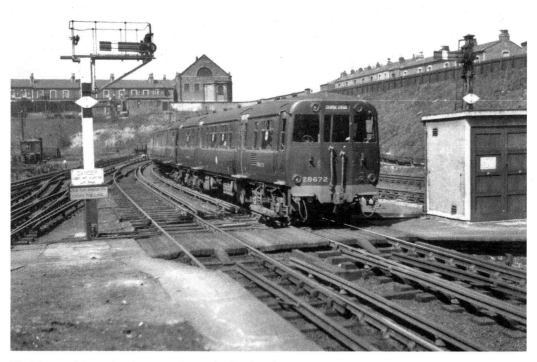

The Liverpool Central train approaches Birkenhead Park Station.

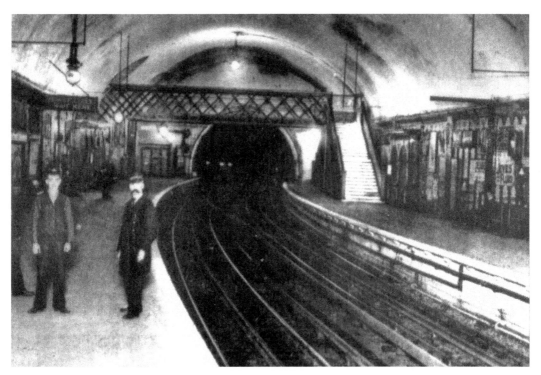

Hamilton Square Station in 1910.

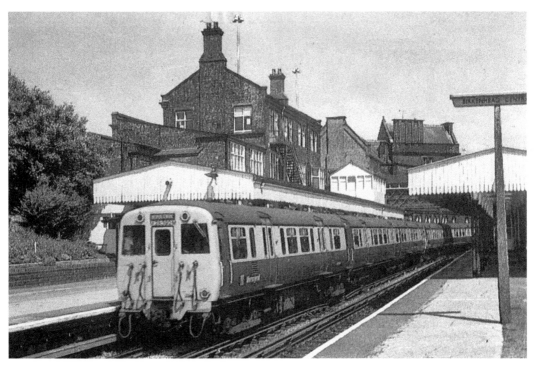

The Rock Ferry to Liverpool Central train leaves Birkenhead Central Station.

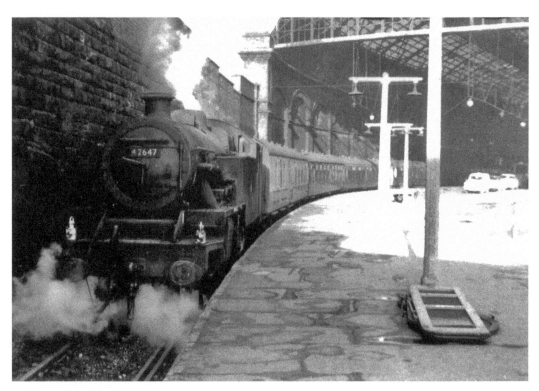

Engine number 42647 steams out of Birkenhead Woodside Station.

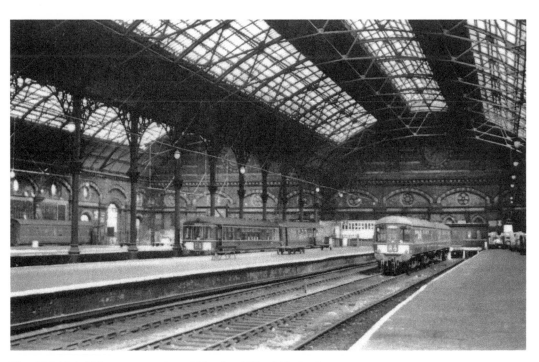

Diesel Multiple Units prepare to leave Birkenhead Woodside Station.

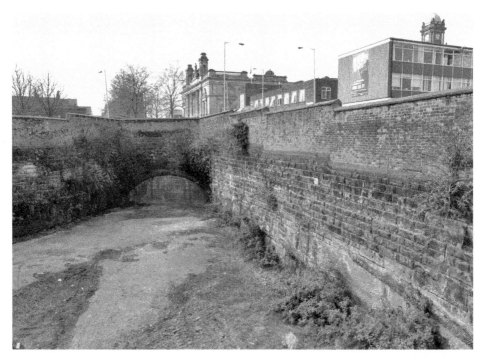

The remains of Woodside Station with Birkenhead Town Hall in the background. The station was opened in 1878, providing services to Chester and beyond until it was closed in 1967 and demolished.

The overgrown dock branch line passes under Argyle Street.

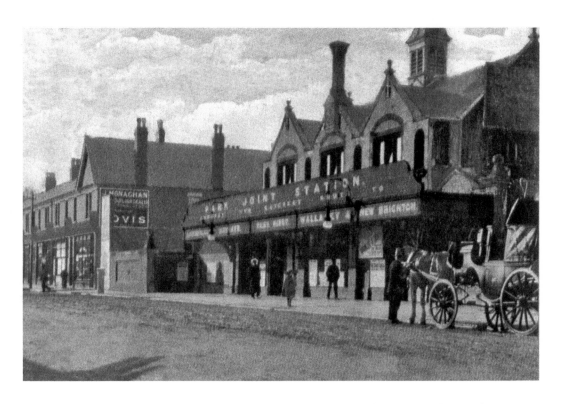

Birkenhead Park Station in Duke Street. The station is on the Liverpool to New Brighton and West Kirby lines.

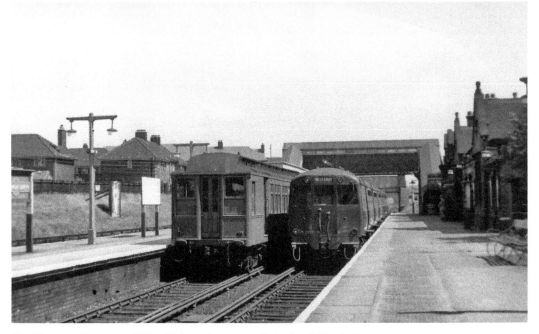

The Liverpool Central and West Kirby trains pass at Birkenhead North Station.

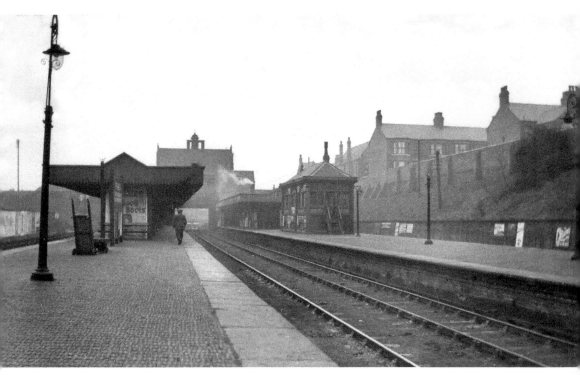

Birkenhead Park Station in 1930.

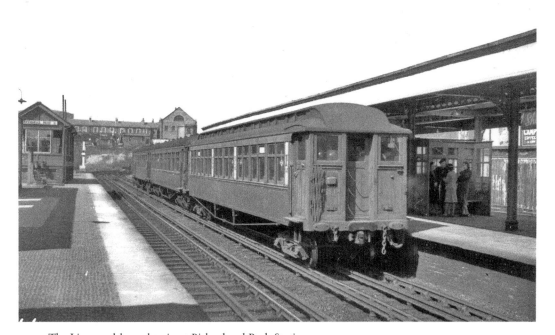

The Liverpool-bound train at Birkenhead Park Station.

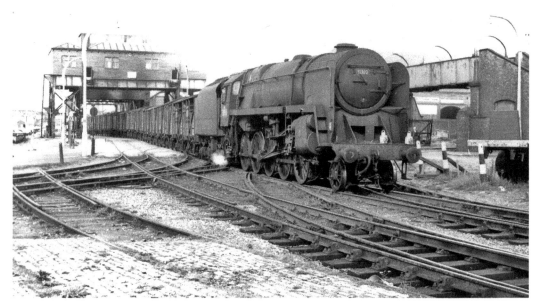

Locomotive no. 92160 passes under Egerton Bridge on the Birkenhead Dock Estate to pass through the dock branch line shown on page 43.

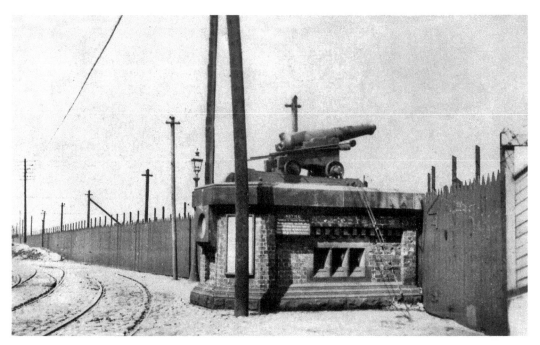

The one o'clock gun at Morpeth Dock. The gun was fired at one o'clock each weekday from 1867. It was fired for the last time in July 1969.

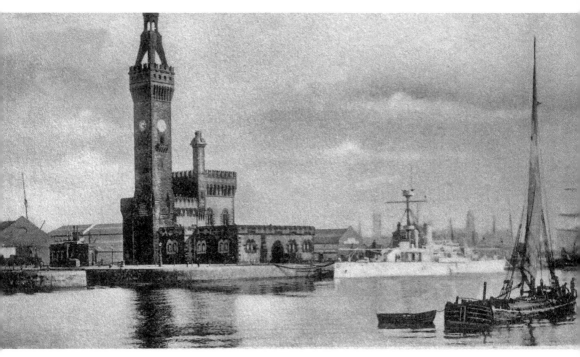

Above and below: The pumphouse and Great Float in Birkenhead docks in 1906. It was built to the design of John Bernard Hartley and completed in 1863, providing power for raising dock bridges and opening the dock gates.

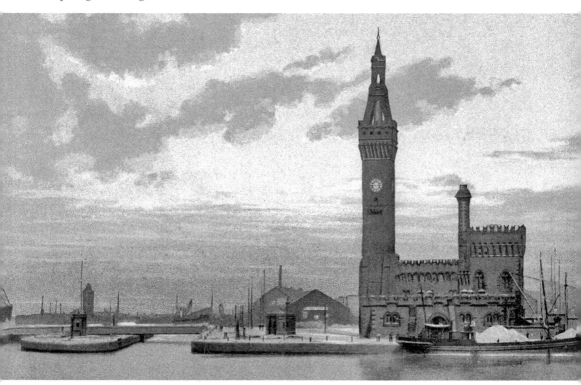

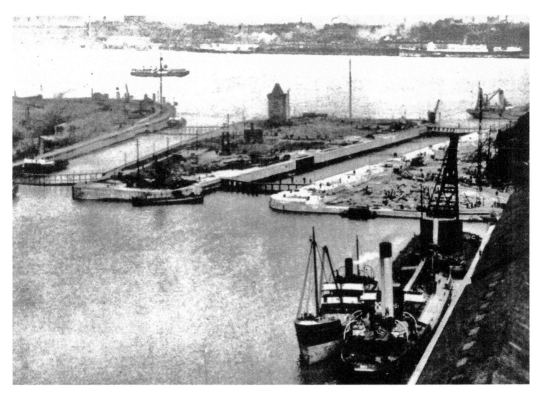

Construction of locks at Alfred Dock, Birkenhead, in the 1920s.

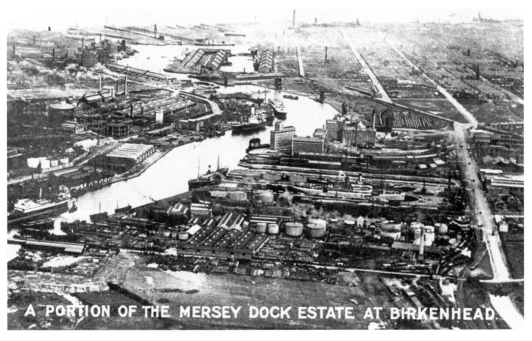

A PORTION OF THE MERSEY DOCK ESTATE AT BIRKENHEAD.

The Dock Estate at Birkenhead and Wallasey.

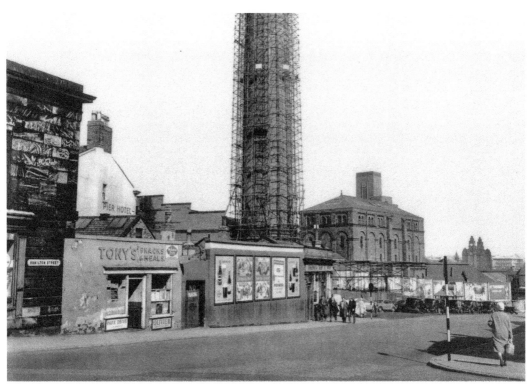

Hamilton Street from Hamilton Square looking down towards Woodside ferry.

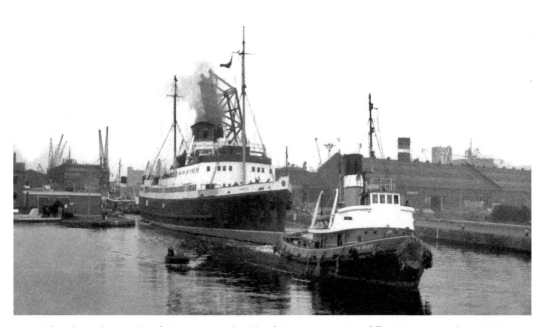

The Alexandra tug *North Buoy* assists the Isle of Man steamer *Snaefell* in Egerton Dock in 1964.

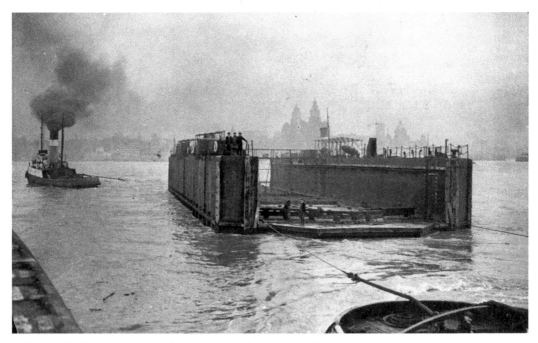

A floating dock leaves Birkenhead on its way to the Far East, July 1945.

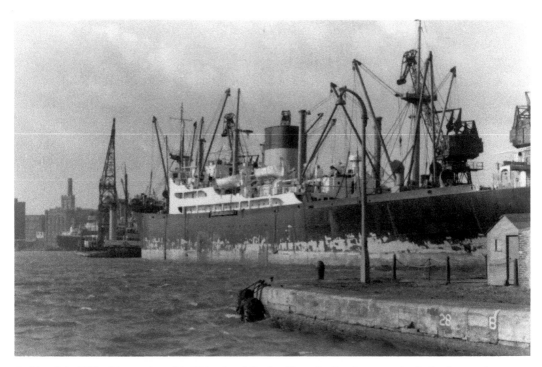

A ship of the Bibby Line anchored in Birkenhead Docks. Note the floating crane in the background to the left.

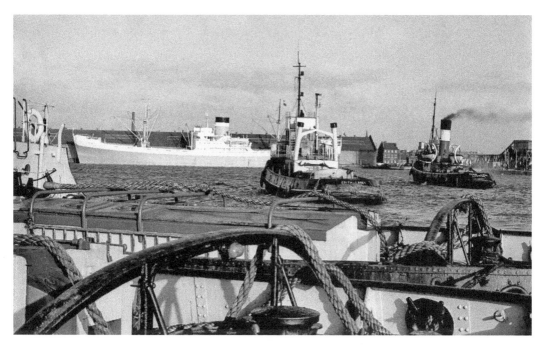

Lamey tugs *Edith Lamey* and *Marie Lamey* and the Ellerman Hall Line's *City of St Albans* in the East Float, Birkenhead.

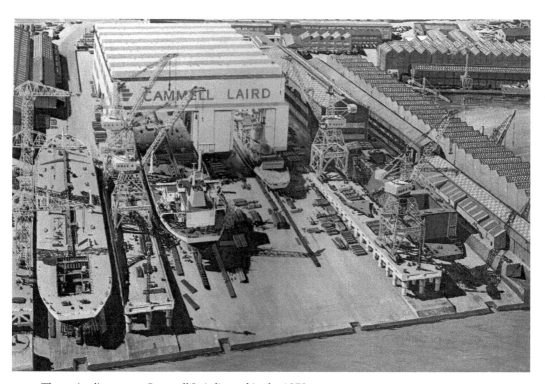

The main slipways at Cammell Laird's yard in the 1970s.

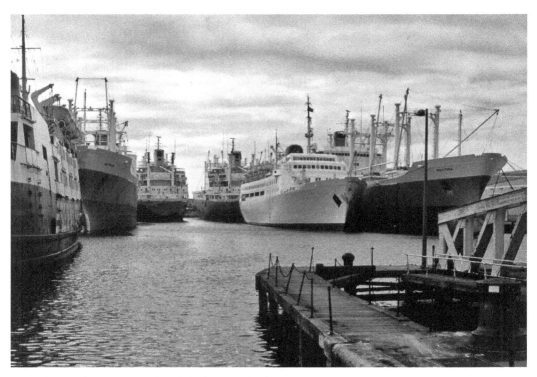

Cunard Line refrigerated vessels and the ferry *England* laid up in Vittoria Dock in 1985.

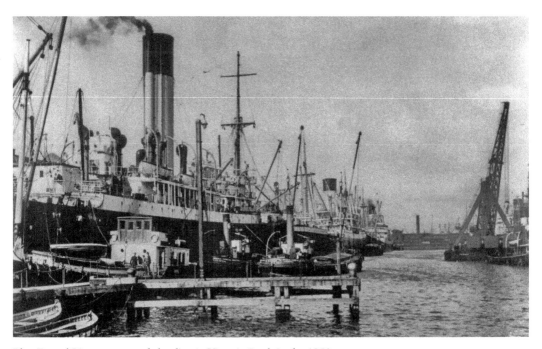

Blue Funnel Line cargo vessels loading in Vittoria Dock in the 1950s.

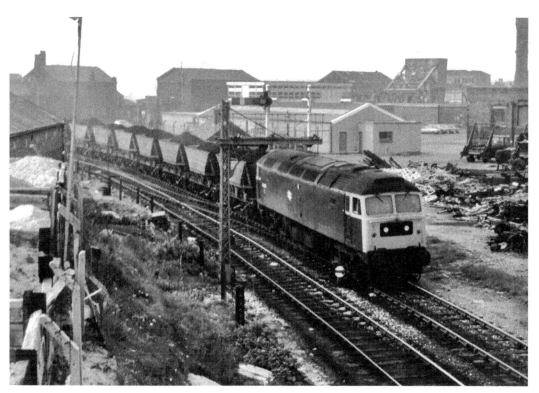

A Class 47 locomotive carries a cargo of coal past the Four Bridges in 1964.

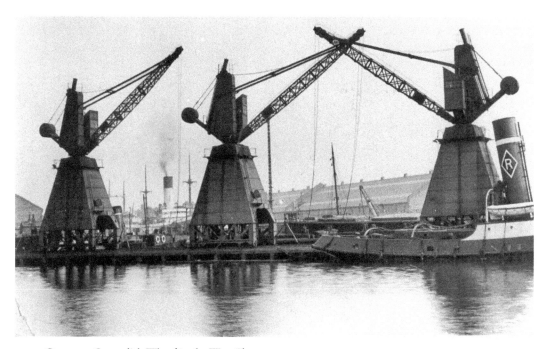

Cranes at Cavendish Wharf in the West Float.

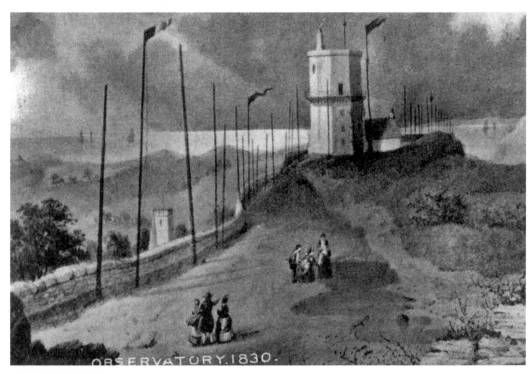

Bidston Hill Lighthouse in 1830. It was built in 1771 and was replaced in 1872.

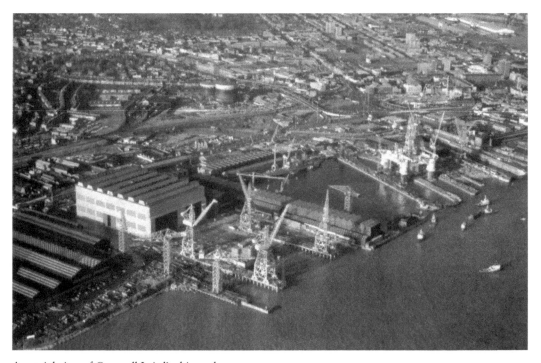

An aerial view of Cammell Laird's shipyard.

Wright & Beyer was founded at the beginning of the twentieth century by Mr P. Wright and Mr Beyer, who was a marine engineer. The business was started in a cottage at the top of Monks Ferry Brow. Mr Beyer left the firm at an early stage and it moved into premises in Ivy Street until 1932. The share capital of the firm of John Marsden & Son was purchased in 1962, and the foundry in Cleveland Street was operated as an associated company.

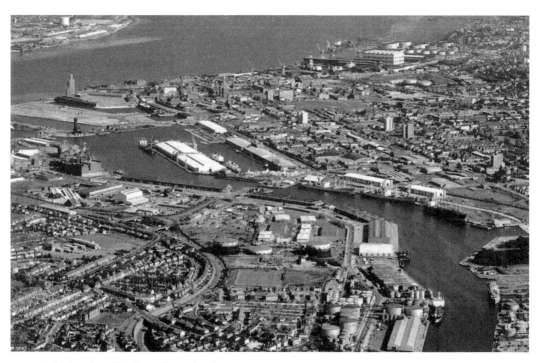

Birkenhead and Wallasey from the air.

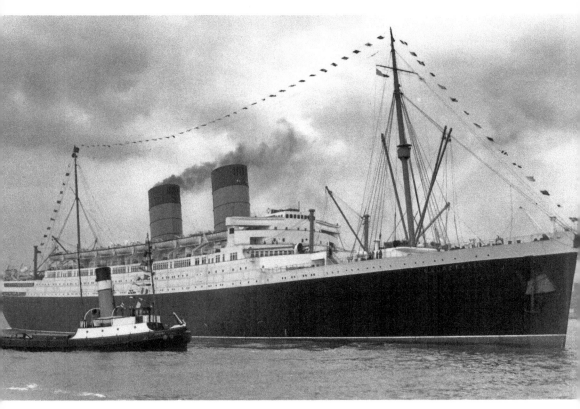

Mauretania, built by Cammell Laird, arriving at Liverpool landing stage to prepare for her maiden voyage on 17 June 1939. She was launched at Birkenhead on 28 July 1938, and was the first ship to be built for the newly formed Cunard White Star Line following the merger of Cunard and White Star lines in 1934. She was powered by two sets of Parsons single reduction-geared steam turbines giving 42,000 shaft horsepower which drove her twin propellers giving her a speed of 23 knots. She was requisitioned by the Admiralty the following year and was converted to use as a troopship.

During the Second World War she travelled 540,000 miles and carried over 340,000 troops, returning to Liverpool in 1946 to be reconditioned and returned to passenger duties. She sailed on her first post-war voyage on 26 April 1947 and was later transferred to use Southampton as her home port. Painted green in 1962, she started a new Mediterranean service calling at New York, Cannes, Genoa and Naples. However, the route was not successful and she was withdrawn, arriving back at Southampton on 10 November 1965. She was sold for scrapping and arrived at Inverkeithing on 23 November that year to be broken up.

Adverts for Cammell Laird Shipbuilders Ltd.

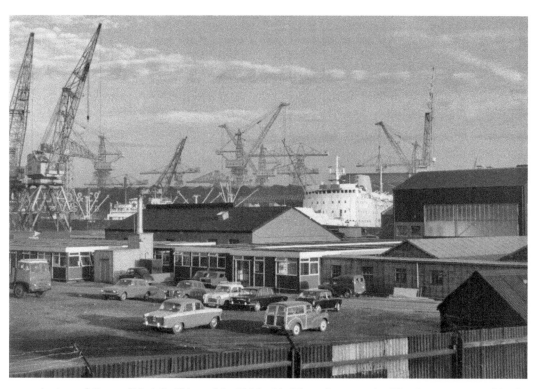

A view of Cammell Laird's Shipyard in 1966 with *Ulster Queen* and a Blue Star cargo vessel in the wet basin.

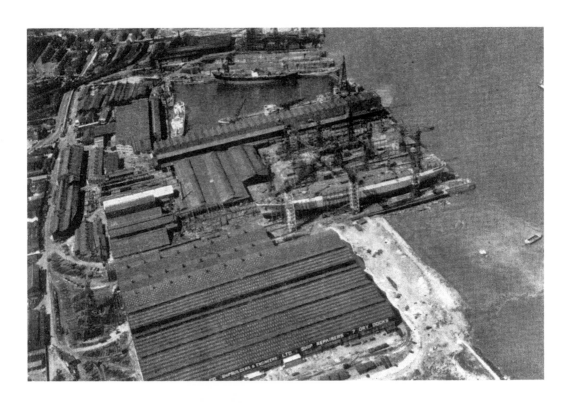

Cammell Laird's wet basin and slipways (*above*), with the Union Castle flagship *Windsor Castle*, prior to her launch by Her Majesty Queen Elizabeth The Queen Mother on 23 June 1959 (*left*).

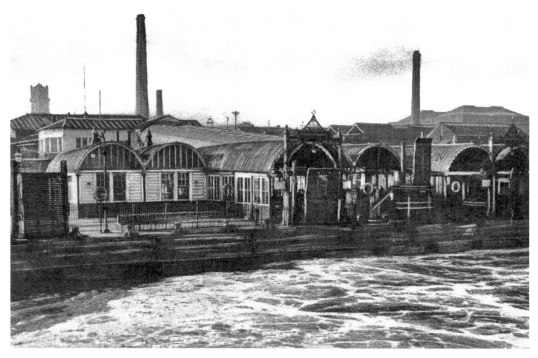

Woodside landing stage in 1958.

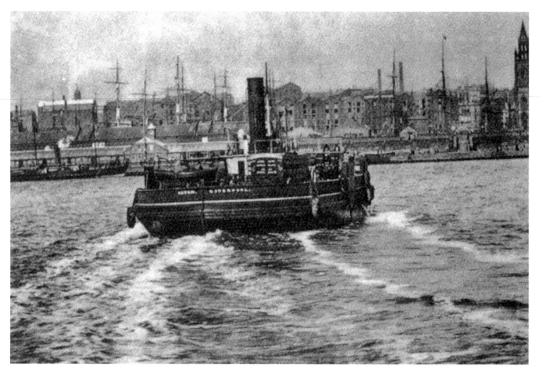

The Birkenhead ferry *Oxton* off Liverpool landing stage.

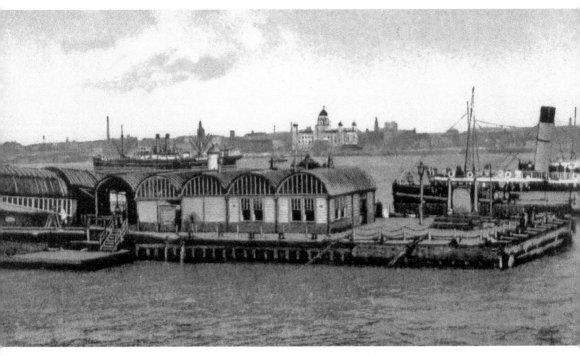

Woodside landing stage.

A postcard from Birkenhead.

BRITAIN'S LARGEST TANKER

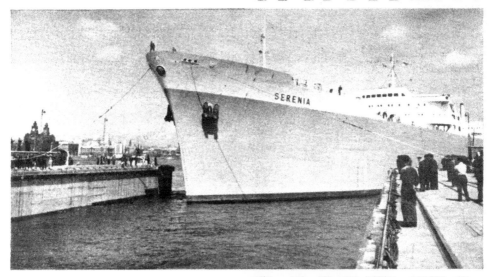

The new 66,790 D.W.T. 'Serenia' entering Grayson Rollo's No. 1 dry dock (one of the four largest in the United Kingdom) prior to acceptance trials on the Clyde. Altogether Grayson Rollo have 5 private dry docks all entered direct from the River Mersey.

CAME TO GRAYSON ROLLO

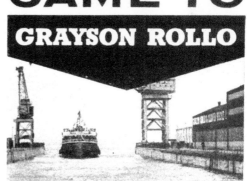

The small photograph shows the Birkenhead ferryboat "Woodchurch" officially opening No. 1 dry dock, 5th October, 1960.

GRAYSON, ROLLO & CLOVER DOCKS LTD

Head Office: SANDHILLS · LIVERPOOL 20 SHIP REPAIRING & MARINE ENGINEERING
Tel: Bootle 1881 'Grams Regulator Liverpool 5 Telex 62436
Offices at LONDON · GLASGOW · NEWCASTLE-UPON-TYNE Facilities for tanker and tank cleaning

This page and following: Grayson, Rollo & Clover's dry docks at Woodside, Birkenhead.

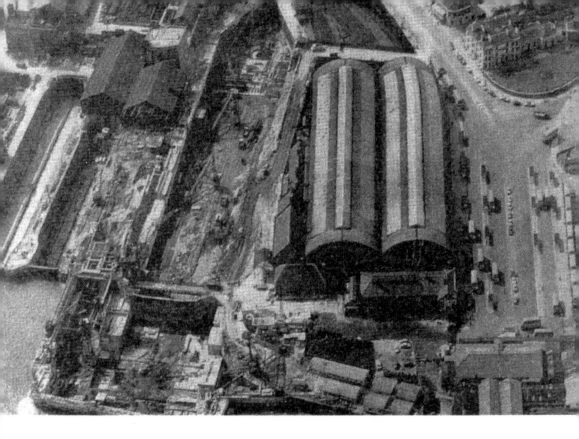

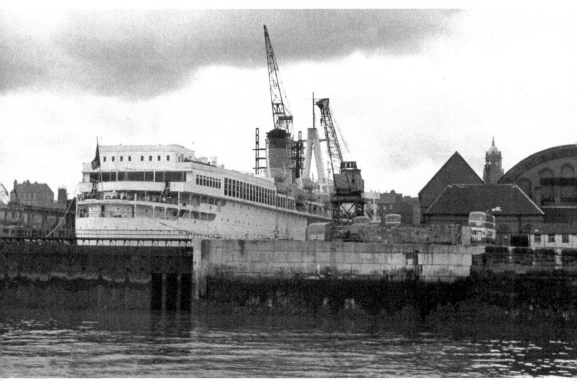

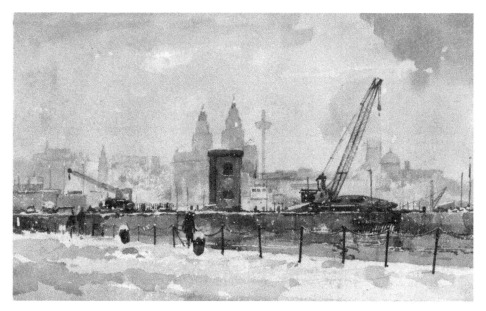

Above: Alfred Dock, Birkenhead, from a watercolour by George Thompson.

Below: Moon Brothers were established in Beaufort Road in 1906 under the name of F. E. Adams Pressure Tool Company Limited. In 1926, the company was taken over by Mr R. B. Moon and the name changed to Moon Brothers Limited. The company specialised in the design and invention of special machinery for the production of cans, drums and vehicle silencers and supplied many of the firms that combined to form the Metal Box Company Limited. Machinery was also sold and exported as early as 1921, and by the 1970s the company was marketing new conveyor systems and became one of Europe's largest manufacturers of can, drum and silencer-making equipment, employing 200 people in 1972.

BRIMLEY & Co. Ltd.

Engineering and Electrical Wholesale Supplies

SHIPS FITTINGS
AND
MARINE
REQUIREMENTS

DOMESTIC
APPLIANCES AND
INDUSTRIAL
EQUIPMENT

187/9 Cleveland Street, Birkenhead L41 3QN

Telephone 051-647 6433 (5 lines)

And at 12 Hanover Street, Liverpool L1 4AB	Tel. 051-709 3553/4
42/44 Copperfield Road, London E.3	Tel. 01-980 1036 Telex 897694
Seaway House, Town Quay, Southampton	Tel. 0703 30434
and Seaway House, Commercial Road, Penryn, Cornwall	Tel. 032-67 3859

Brimley & Company Limited was founded in 1871 as engineers' merchants, and by the 1970s was one of the principal electrical wholesalers with branches in Liverpool and London. They also specialised in marine electrical supplies and were distributers of European, Japanese, Scandinavian and American material for ships.

Valvoline Oil Company was established in 1866 on the Dock Road at Birkenhead. It was taken over by Ashland Oil Incorporated of Ashland, Kentucky, and specialised in automotive and industrial lubricants and rust preventatives.

Victory-Kidder Limited was incorporated in 1872 to build printing machinery. They provided high-speed central impression, flexographic machines for the multi-colour printing of transparent and extensible packaging material such as polyethylene, cellulose film and polypropylene as well as paper-cutting machinery to the printing trade all over the world.

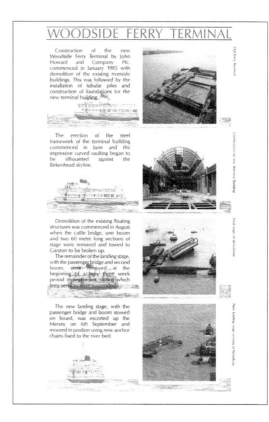

WOODSIDE FERRY TERMINAL

Construction of the new Woodside Ferry Terminal by John Howard and Company Plc. commenced in January 1985 with demolition of the existing riverside buildings. This was followed by the installation of tubular piles and construction of foundations for the new terminal building.

The erection of the steel framework of the terminal building commenced in June and the impressive curved vaulting began to be silhouetted against the Birkenhead skyline.

Demolition of the existing floating structures was commenced in August when the cattle bridge, one boom and two 60 metre long sections of stage were removed and towed to Garston to be broken up.
The remainder of the landing stage, with the passenger bridge and second boom, were removed, at the beginning of a busy three week period in September, during which ferry services were suspended.

The new landing stage, with the passenger bridge and boom stowed on board, was escorted up the Mersey on 6th September and moored in position using new anchor chains fixed to the river bed.

Birkenhead Woodside ferry terminal was replaced in 1985.

THROUGH RETURN FARES

FERRIES . . .

and MOTOR BUSES . . .

From Liverpool Landing Stage (via Woodside Day Boats)

(Book at the Turnstiles, Woodside Ferry)

	ADULTS	CHILDREN UNDER 14
Arrowe Park Gates	10d.	5d.
*Arrowe House Farm	10d.	5d.
Barnston (via "Crosville" only)	1/2	6d.
Bidston Village	8d.	4d.
Bromborough Cross	10d.	5d.
Bromborough Pool Lane End	8d.	5d.
*Eastham Village	1/-	6d.
*Heswall	1/4	7d.
Landican Lane	8d.	5d.
Leasowe, Reeds Lane	8d.	4d.
Lower Bebington Village	8d.	5d.
Moreton, via Arrowe	1/-	6d.
Moreton, via Bidston	10d.	5d.
Oaklea Road, near Irby	1/-	6d.
Pensby (via "Crosville" only)	1/2	6d.
Spital Cross Roads	8d.	5d.
*Thingwall Corner	1/	6d.
Thurstaston (via Irby)	1/2	6d.
Upton Manor (via Arrowe)	10d.	5d.
Upton Cricket Ground	10d.	5d.
Upton Station	8d.	5d.

* Also available via "CROSVILLE" Buses.

Available for return by Passenger Day Boats, on day of issue or following day. Tickets issued on Saturdays are available for return on the following Sunday or Monday.

SEE PAGE 3 **NO LUGGAGE ALLOWED**

Tickets are issued subject to Byelaws, Rules and Regulations of the Corporation *vide* Notices.

Ferry and bus 'Through Return Fares' in 1939.

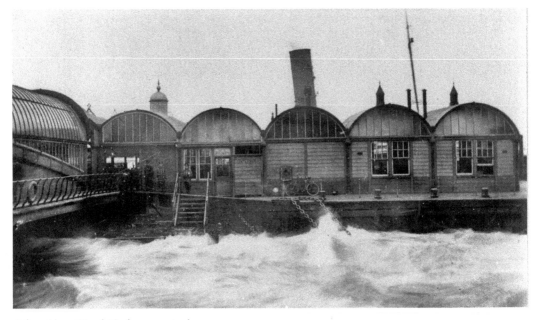

A fast tide at Woodside ferry terminal.

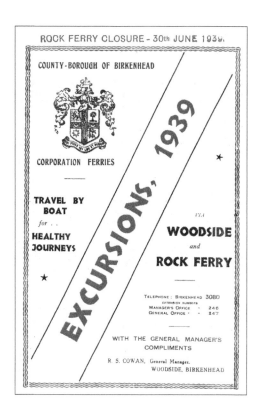

ROCK FERRY CLOSURE - 30th JUNE 1939.

COUNTY-BOROUGH OF BIRKENHEAD

CORPORATION FERRIES

TRAVEL BY
BOAT
for . .
HEALTHY
JOURNEYS

EXCURSIONS, 1939

WOODSIDE
and
ROCK FERRY

TELEPHONE : BIRKENHEAD 3080
EXTENSION NUMBERS
MANAGER'S OFFICE - 246
GENERAL OFFICE - 247

WITH THE GENERAL MANAGER'S
COMPLIMENTS

R. S. COWAN, General Manager,
WOODSIDE, BIRKENHEAD

Birkenhead ferry excursions leaflet for 1939
showing details of the Rock Ferry service closure
on 30 June that year.

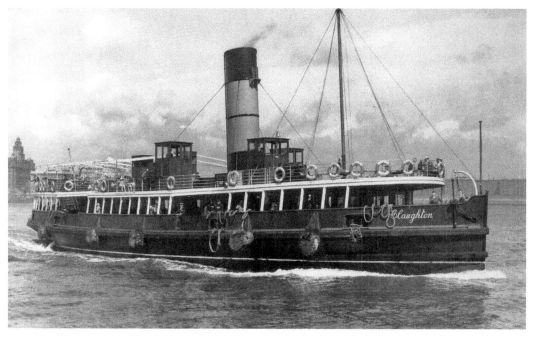

The Birkenhead ferry *Claughton*. She was built by Cammell Laird at Birkenhead in 1930, and was certified to carry 1,433 passengers. She was sold and broken up at Ghent in 1962.

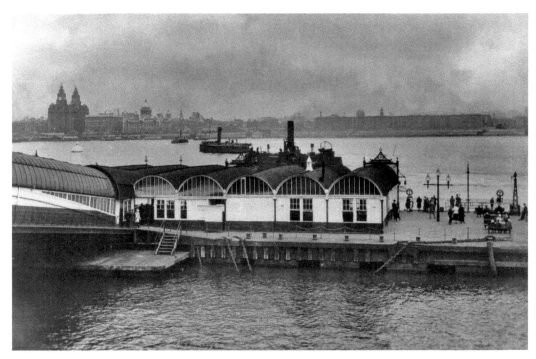

Three Birkenhead ferries on the Woodside to Liverpool Pier Head service.

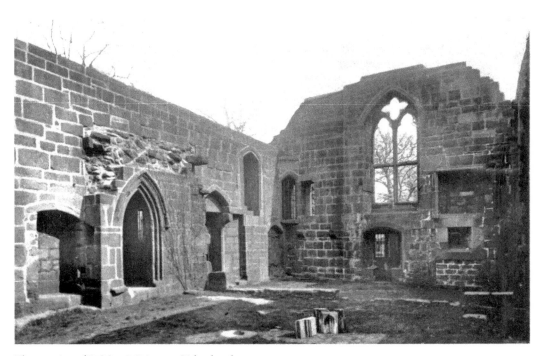

The remains of St Mary's Priory at Birkenhead.

Cheap fares on the Woodside and Rock Ferry services in 1939.

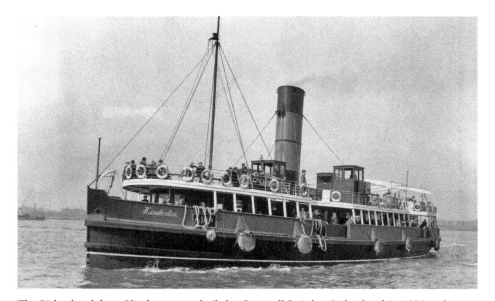

The Birkenhead ferry *Hinderton* was built by Cammell Laird at Birkenhead in 1925 and was a sister ship of *Claughton*. *Hinderton* was withdrawn from service on 13 May 1956 and sold to ship-breakers in Antwerp two years later.

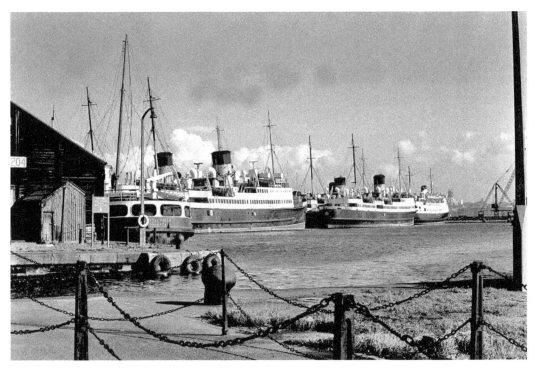

The Mersey ferry *Woodchurch* and Isle of Man Steam Packet vessels laid up in Morpeth Dock in 1968.

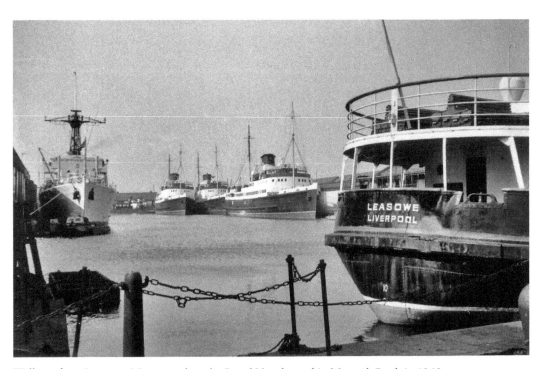

Wallasey ferry *Leasowe*, Manx vessels and a Royal Naval vessel in Morpeth Dock in 1965.

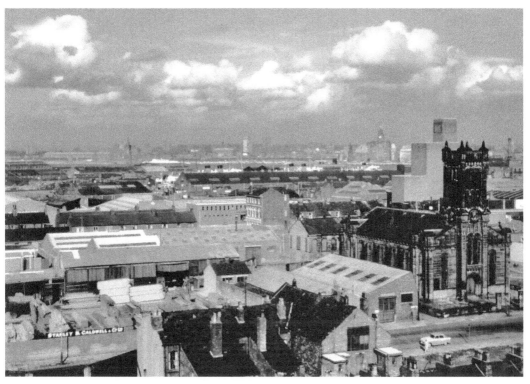

A view of central Birkenhead and docks taken from Eldon Gardens in 1964.

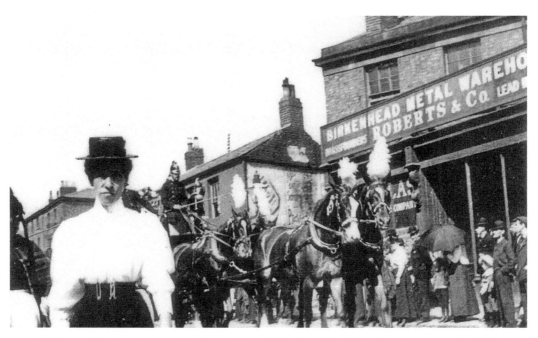

While participating in a parade, a horse-drawn Birkenhead Fire Brigade engine passes the Birkenhead Metal Warehouse in Argyle Street.

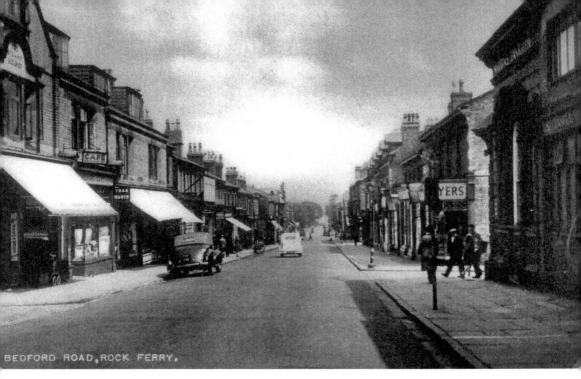

Bedford Road, Rock ferry.

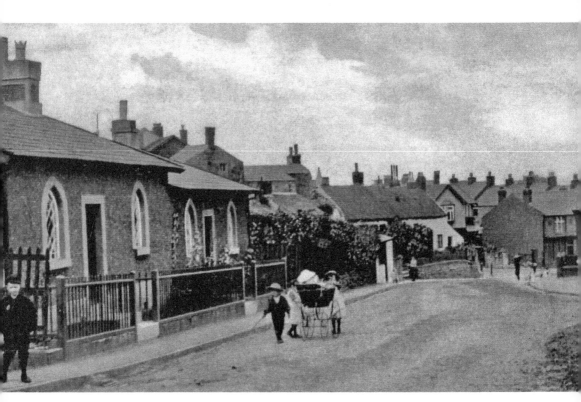

Higher Bebington, *c.* 1900.

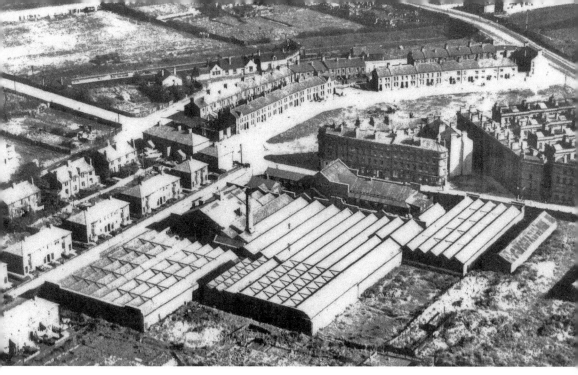

The Dock Road and the north end of Birkenhead.

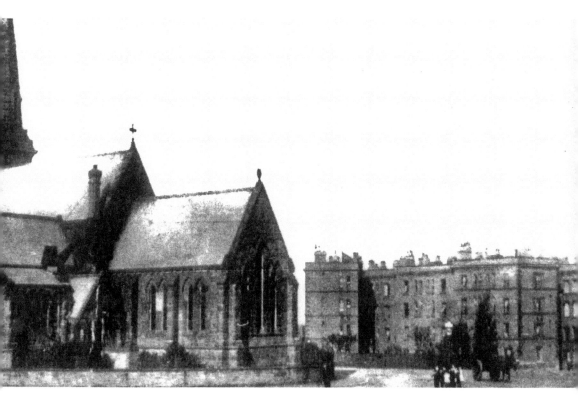

St James' church, Birkenhead.

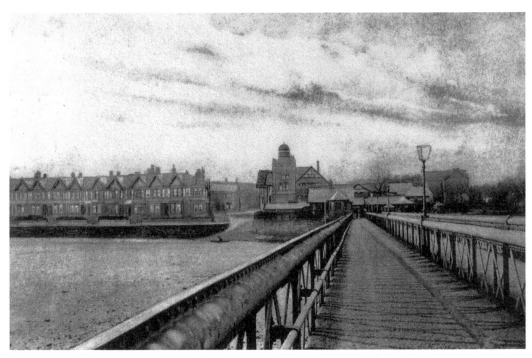

New Ferry Pier was opened in 1865 and was 856 feet long. Vessels owned by the Mersey River Steam Boat Company provided a service to Liverpool from the pier.

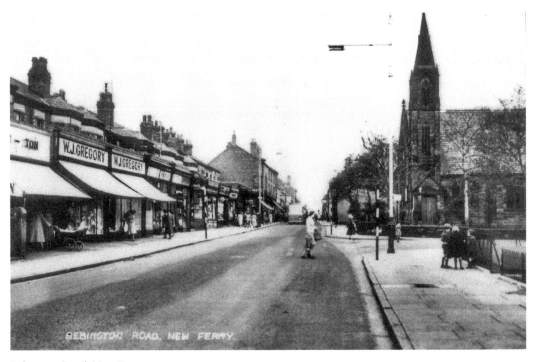

Bebington Road, New Ferry.

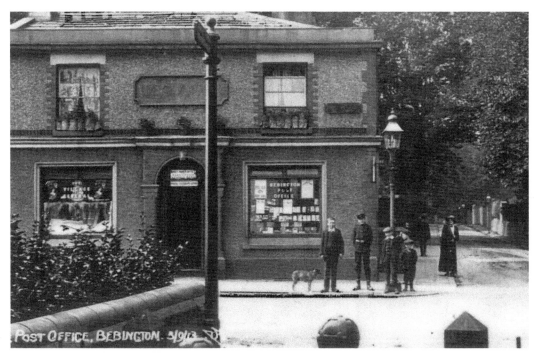

The Post Office at Bebington in 1913.

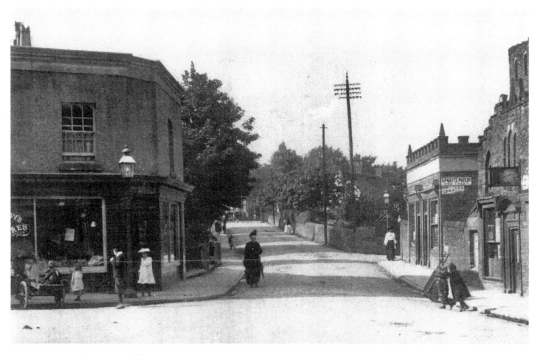

Lower Bebington Village.

Bedford Road, Rock Ferry.

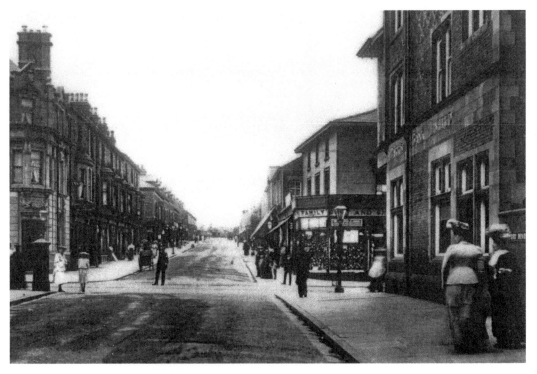

Another view of Bedford Road, Rock Ferry.

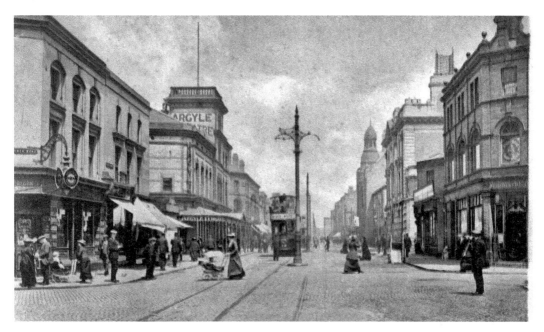

The Argyle Theatre and Hotel in Argyle Street, Birkenhead. It was opened on 21 December 1868 by Dennis Grennell, and in 1876 it was renamed the Prince of Wales Theatre. However, when it was managed by Dennis J. Clarke between 1888 and 1934, the name Argyle was restored and it became one of the country's most famous music halls. Charlie Chaplin, W. C. Fields, G. H. Elliot, George Formby, Stan Laurel and Donald Peers all appeared on the stage at the theatre. On 21 September 1940 it took a direct hit from German bombers and was destroyed by fire.

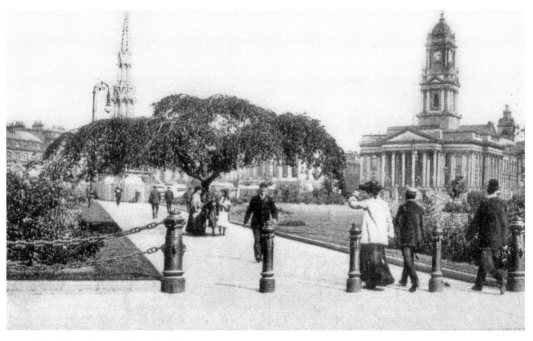

Hamilton Square, Birkenhead.

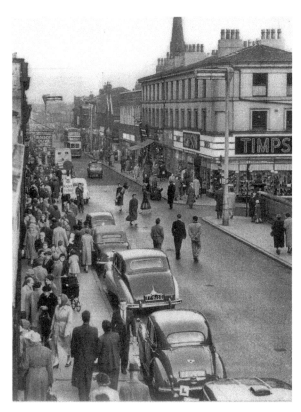

A busy Saturday morning in Grange Road.

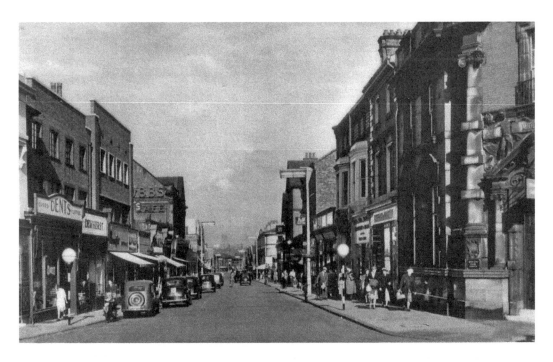

Looking down Grange Road from Charing Cross.

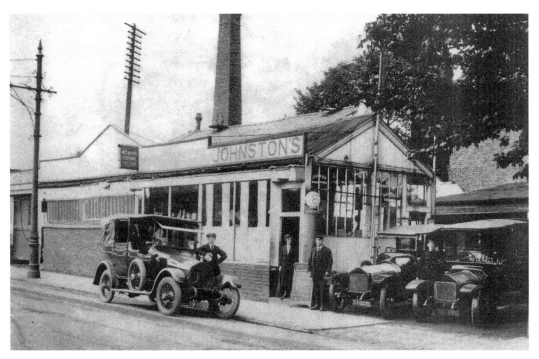

John and Edward Johnston operated a taxi business in Borough Road. In addition to the taxi firm, they ran a bus service to Heswall with a thirty-two-seat Leyland vehicle and a twenty-seat Daimler. The service was sold to the Harding bus company in 1924, who sold it to Crosville the following year.

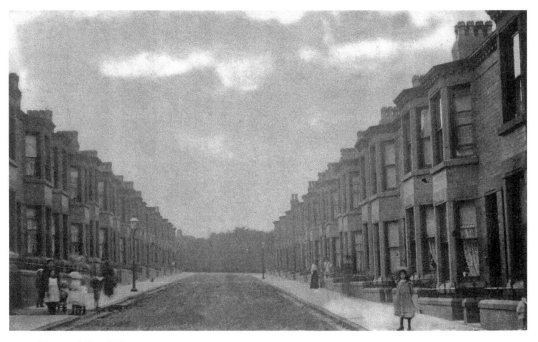

Linwood Road, Tranmere.

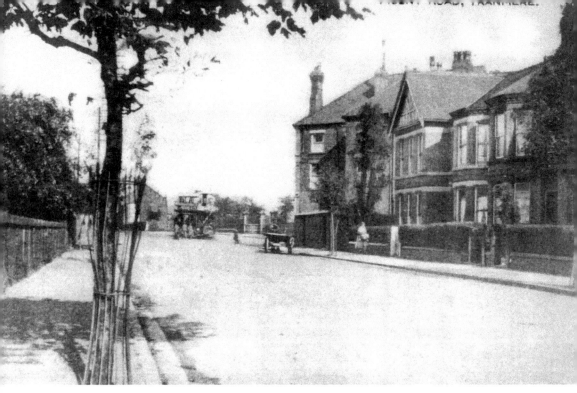

Mount Road, Tranmere.

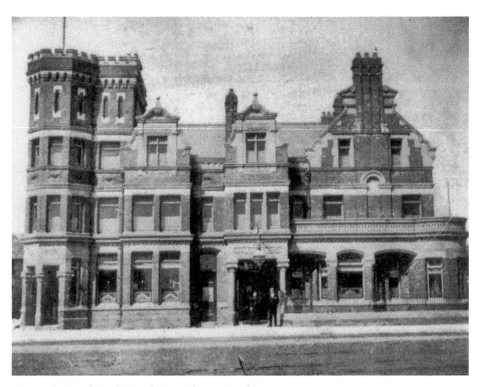

Ormerod's Royal Castle Hotel, New Chester Road.

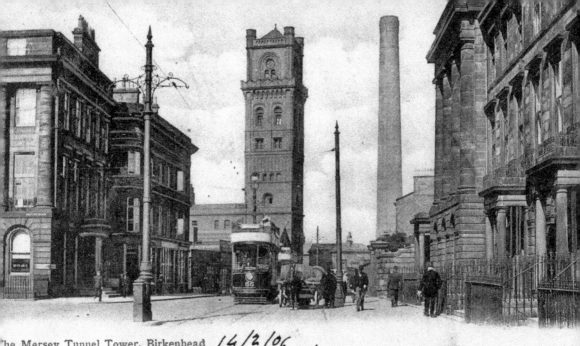

The Mersey Tunnel Tower, Birkenhead 14/2/06 *zenaide Gras*

Hamilton Square and Hamilton
Square Railway Station in 1906.

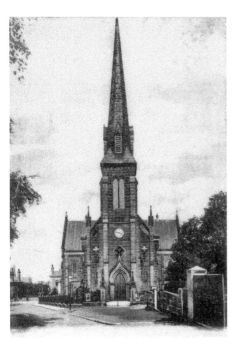

Christ Church in Claughton was built in 1849, but was not dedicated until May 1854. Schoolrooms were incorporated in the plans, but the increase in demand for educational facilities locally led to the Claughton Higher Grade School opening in 1883 in nearby Borough Road.

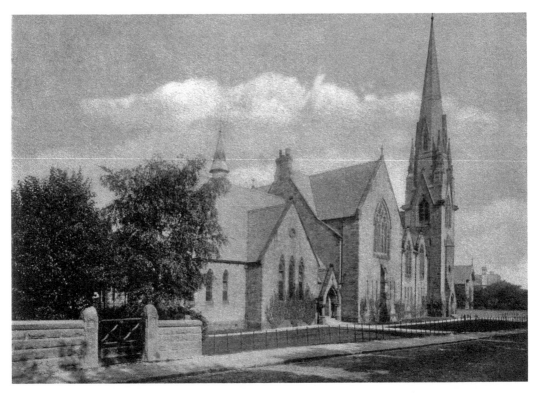

Trinity church in Claughton was opened on 11 October 1866. A new vestry, session and committee rooms were added in 1892, and in 1977 the church went into partnership with Palm Grove Methodists.

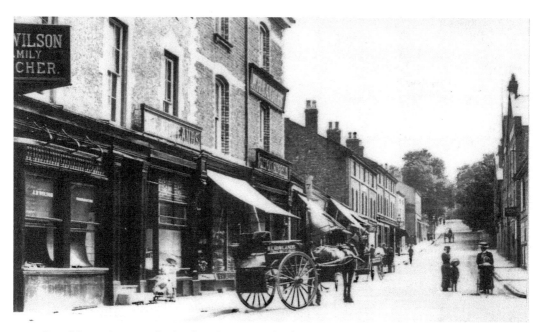

Rose Mount, Oxton, Birkenhead, in the 1920s. The shops (left to right) are Herbert Rowlands, poulterer; Arthur Rowlands, fruiterer; Selves, confectioner; J. S. Cooke, boot repairer; F. Tutty, ironmonger; Miss White, milliner; J. Fletcher, grocer; Bertha Young, draper; and Miss Crowhurst, confectioner.

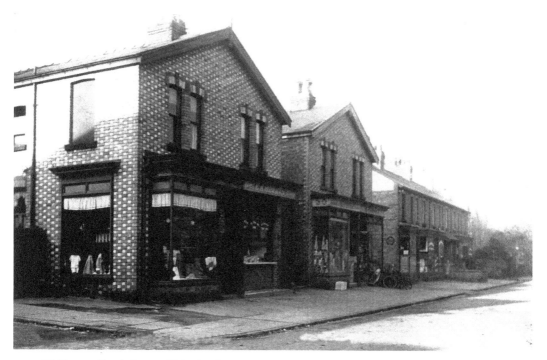

Wellington Road, Oxton, Birkenhead.

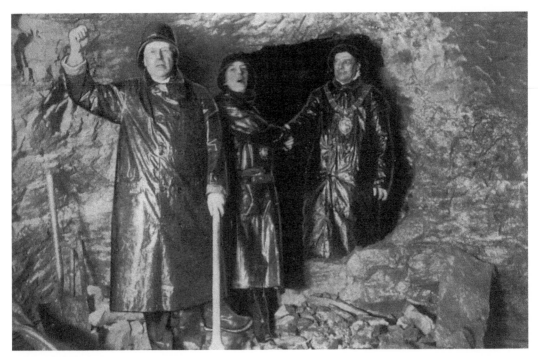

The 'holing through' ceremony by Sir Archibald Salvidge; the Lord Mayor of Liverpool, Mrs Margaret Beavan; and the Mayor of Birkenhead, Alderman F. Naylor. Mr Basil Mott and John A. Brodie(joint engineers), Walter Moon (clerk), Mr G. G. Lynde (contractors), Mr J. Gibbins (MP), and Mrs Mercer (ex-Mayor of Birkenhead) were also present at the ceremony on 3 April 1928.

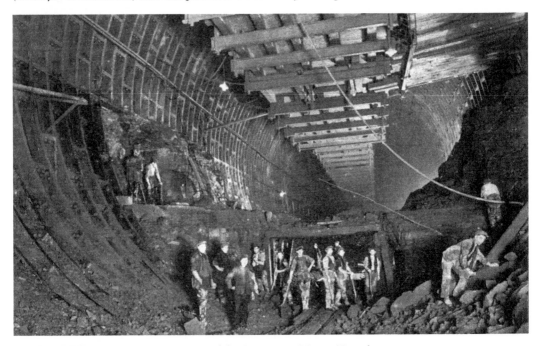

Above and following page: Construction of the Queensway Mersey Tunnel.

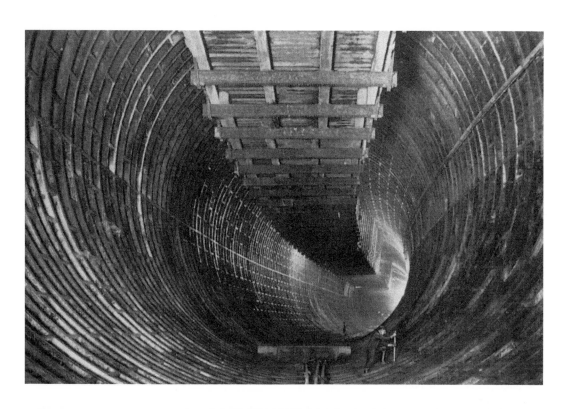

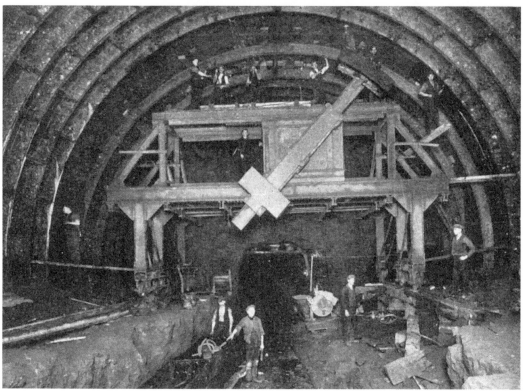

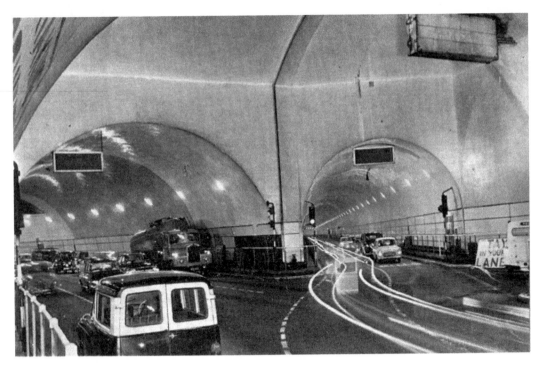

The Dock Road junction in the Queensway Tunnel.

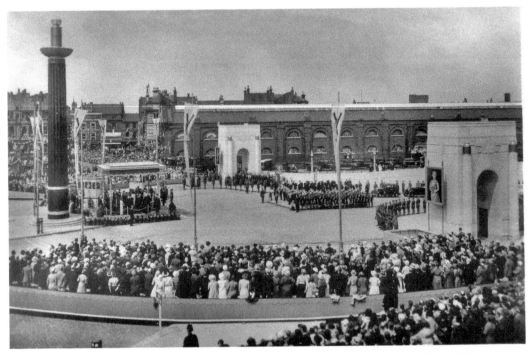

The opening of the Queensway Tunnel by His Majesty King George V and Queen Mary on 18 July 1934.

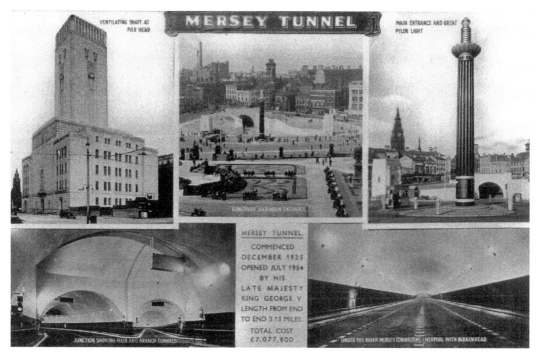

Mersey Tunnel postcard.

The Arno, Birkenhead, in 1905. The Arno was originally a quarry supplying red sandstone, and was purchased by Birkenhead Corporation in 1912 and opened to the public as a recreational area.

William Cubbin Limited was founded in 1902 and specialised in the repair and maintenance of tugs, barges and other small craft. The premises included a well-equipped machine shop staffed by experienced engineers. The yard was at the West Float, at Wallasey Bridge Road, and included two slipways capable of taking vessels of up to 150 feet in length. Testing and repair of all types of lifting equipment and appliance to Docks and Factory Regulations standard was undertaken and the comprehensive equipment included heat-treatment furnaces, atomic hydrogen welding plant and a chain-testing machine of 160 tons capacity for certification of heavy-lifting gear.

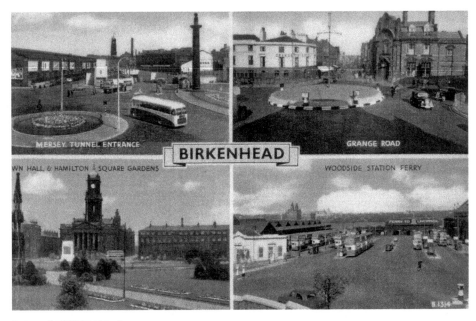

Postcard of Birkenhead.

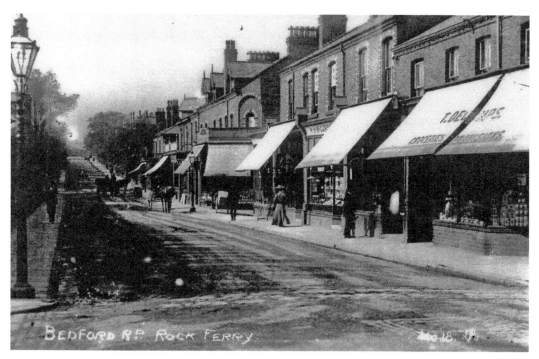

Bedford Road, Rock Ferry.

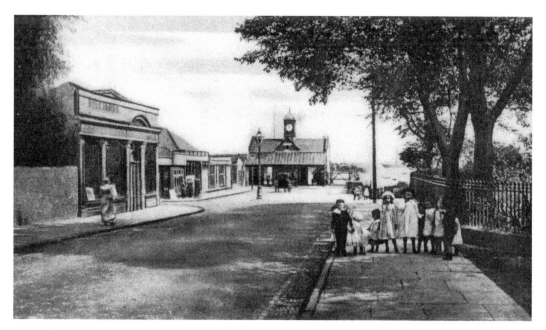

The approach road to the ferry at Rock Ferry. The ferry was purchased by Joseph White in 1805 and sold to Thomas Morecroft in 1820. The Royal Rock Ferry Company was formed in 1836 to operate the service. It was taken over by the Corporation of Birkenhead in 1897 and operated until the service was closed on 30 June 1939.

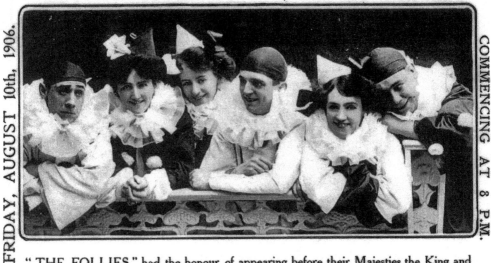

OLYMPIAN GARDENS, ROCK FERRY.

FRIDAY, AUGUST 10th, 1906.

COMMENCING AT 8 P.M.

" THE FOLLIES," had the honour of appearing before their Majesties the King and
Queen, at Sandringham, on December 1st, 1905, on the occasion of the Queen's Birthday.

The Follies appeared at the Olympian Gardens, Rock Ferry, on 10 August 1906. They had appeared
before the King and Queen at Sandringham on 1 December the previous year, on the occasion of the
Queen's birthday.

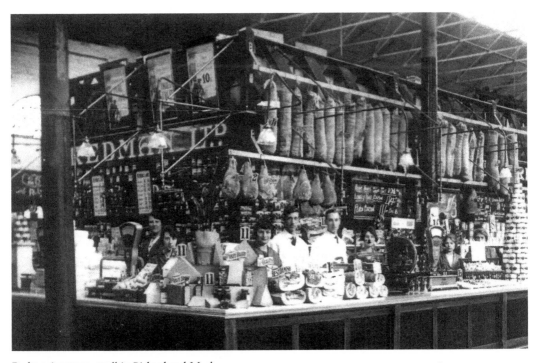

Redman's grocery stall in Birkenhead Market.

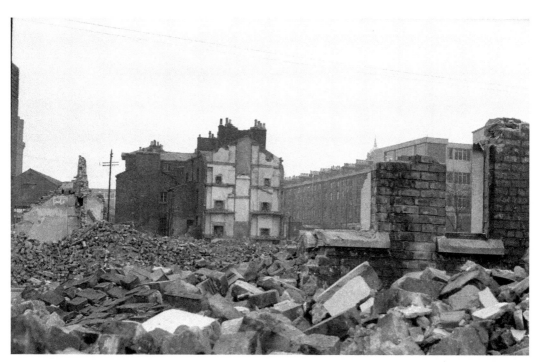

Above and below: Demolition of Victorian properties in central Birkenhead in the 1960s. The photographs were taken around Bridge Street and Canning Street; the rear of properties in Hamilton Square can be clearly seen in the top photograph, and the top of the Town Hall can be seen on the left of the bottom photograph.

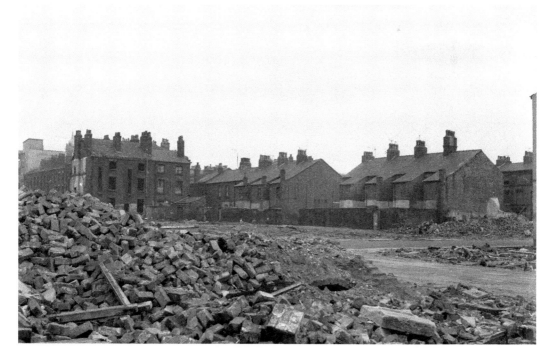

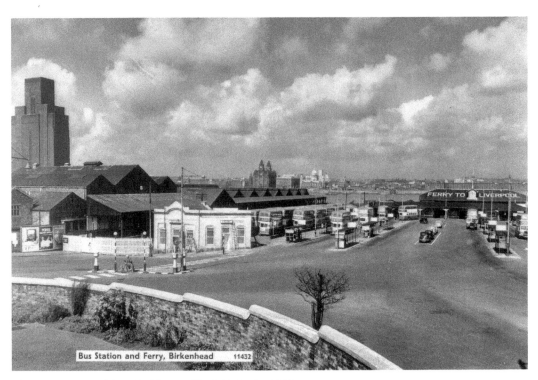

The Bus Station and ferry building at Woodside in the 1960s.

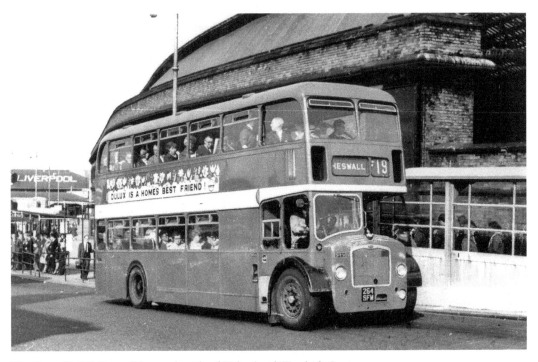

The Crosville F19 Heswall bus at the side of Birkenhead Woodside Station.

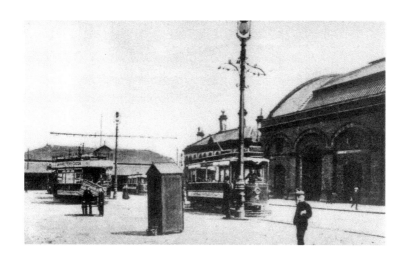

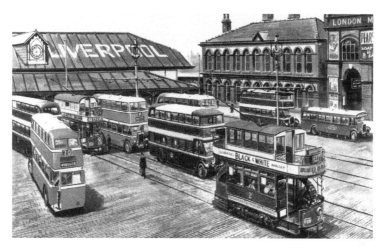

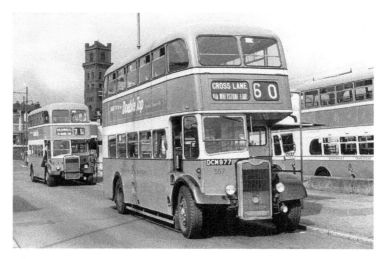

This page: Birkenhead Corporation trams and buses at the Woodside terminal.

The Toll Bar at New Ferry. The tolls operated in New Chester Road until 1872.

Birkenhead Corporation No. 77, Woodside to Moreton Shore via Singleton Avenue.

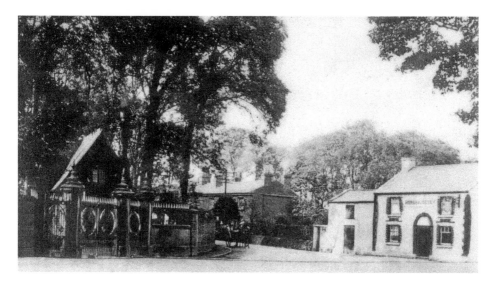

Above: Arrowe Park gates and the Horse & Jockey Public House.

Right: Stanley B. Caldwell & Company Limited was established in the 1930s and is involved in importing and supplying all classes of timber catering for shipping companies, ship repairers, stevedores, civil engineering firms, large and small contractors, house builders and all users of timber. All classes of softwoods, hardwoods, wallboards, plywood, mouldings and doors are supplied by the company.

Below: A policeman directs traffic in Conway Street at the junction with Argyle Street.

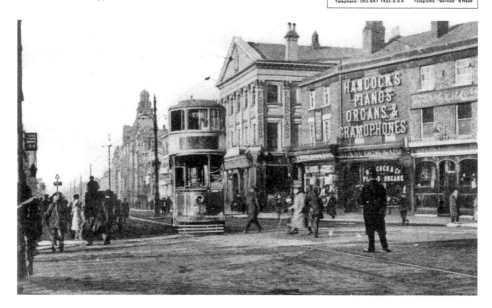

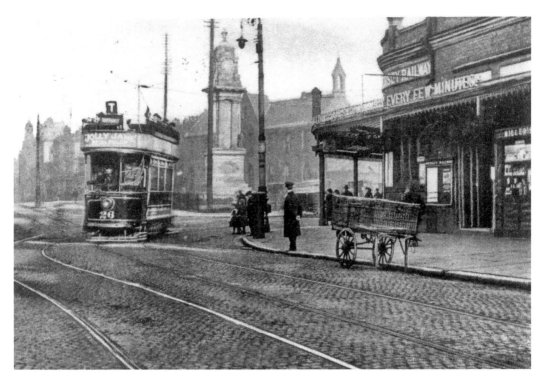

A tramcar passes the entrance to Birkenhead Central Station.

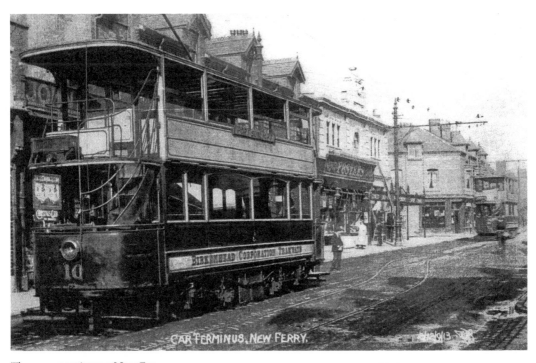

The tram terminus at New Ferry.

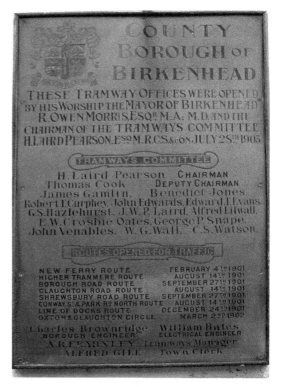

The Tramway Office opened by the Mayor of Birkenhead, R. Owen Morris, and the Chairman of the Tramways Committee, H. Laird Pearson, on 28 July 1903.

The plaque gives details of the opening of the Tramways routes:

New Ferry Route – 4 February 1901.

Higher Tranmere Route – 14 August 1901.

Borough Road Route – 27 September 1901.

Claughton Road Route – 14 August 1901.

Shrewsbury Road Route – 27 September 1901.

Conway Street and Park Road North Route – 14 August 1901.

Line of Docks Route – 24 December 1901.

Oxton and Claughton Circle – 2 March 1902.

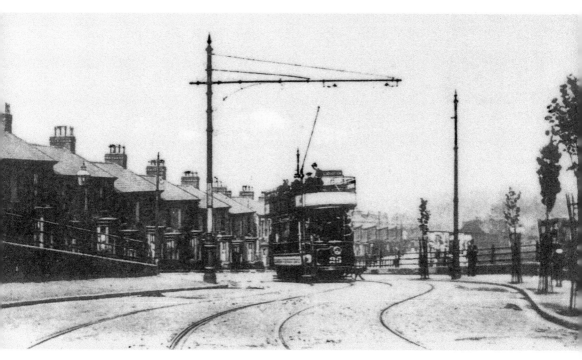

A tram heads up the hill at Argyle Street South.

William Bernard Limited was founded in 1891, in premises in Grange Road. During the 1941 bombing a 500 lb high-explosive bomb shattered the building in Hamilton Street to which the firm had moved. By 1961 they completed part of the programme of expansion and development in Hamilton Street. In the early 1970s they moved to modern premises in Chester Street which included a showroom, counter sales area, offices and warehouse space. In 1946 a branch of the company was established in Rhyl, North Wales, which allowed them to serve Merseyside, Lancashire, Cheshire and the whole of North Wales, including Anglesey.

Dun Henry Collins founded D. H. Collins & Sons Limited in 1850. They are steel stockholders and engineers' merchants with a comprehensive stock of steel sections, bolts, nuts, washers, nails and other engineers' and builders' requirements. With the building of the Mersey Tunnel approach roads, they moved to Sandford Street premises in 1967 and they also have offices and warehouses in Anson Place in Liverpool.

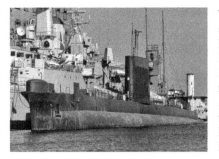

The Historic Warship Collection was an important tourist attraction in Birkenhead Docks. It included HMS *Onyx*; HMS *Plymouth*; HMS *Bronington*; the landing craft, tank LCT 7074; the German U-boat U 534; and the Mersey Bar lightship *Planet*. It was situated in the East Float near the Victorian grain warehouses. The submarine U 534 was moved when planning permission was given for the warehouses to be converted to luxury apartments. In February 2006, the Trust announced its voluntary liquidation and that the museum would close.

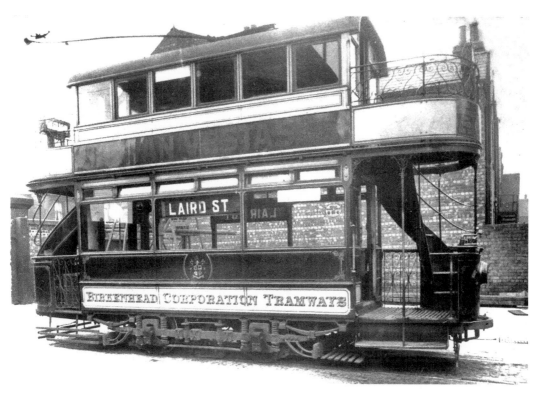

Birkenhead Corporation Tramways vehicle parked in Laird Street Depot.

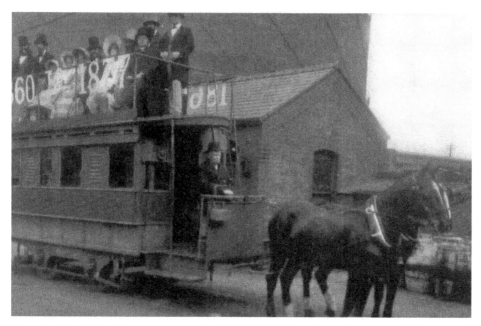

Horse-drawn tram on display in 1927.

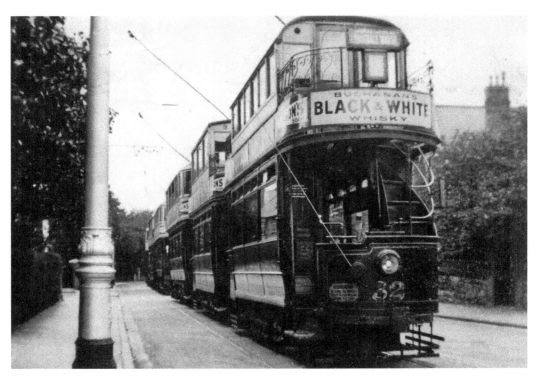

Trams parked in Prenton Road.

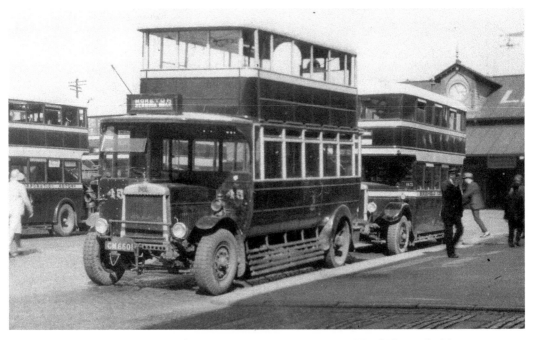

Birkenhead Corporation vehicle number 45, registration no. CM6601 at Woodside, on the Moreton to Bermuda Road service.

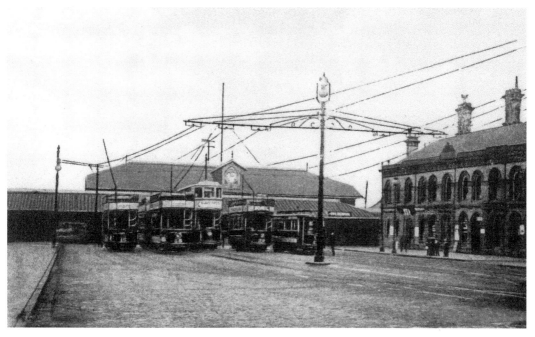

Trams at Woodside waiting for the ferry from Liverpool to arrive.

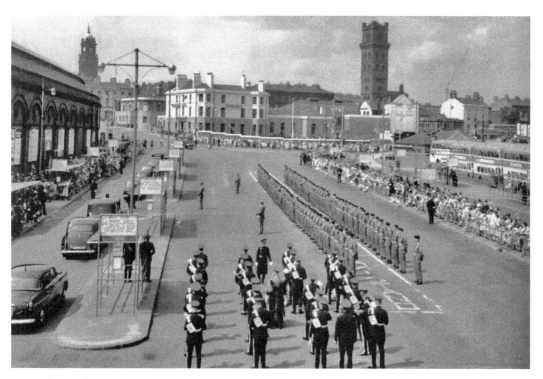

The royal car awaits Her Majesty Queen Elizabeth The Queen Mother at Woodside to convey her to Cammell Laird's yard to launch the Union Castle liner *Windsor Castle* on 23 June 1959.

Conway Street, Birkenhead.

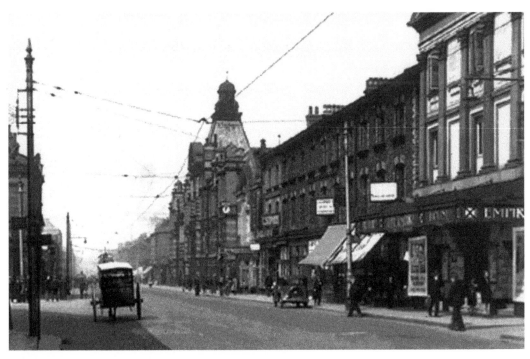

Conway Street in the early 1930s, showing the Empire Picture House. It was opened in 1917 and was the last cinema in Birkenhead when it closed in 1991.

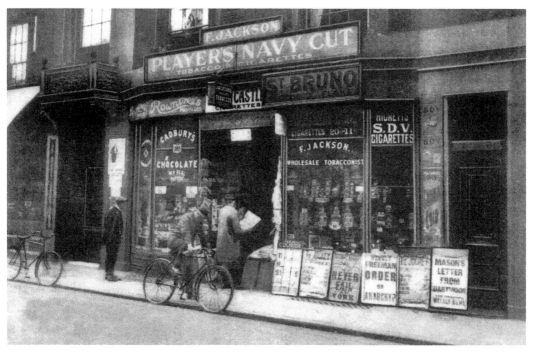

F. Jackson's shop in Cross Street, near the Market in Birkenhead.

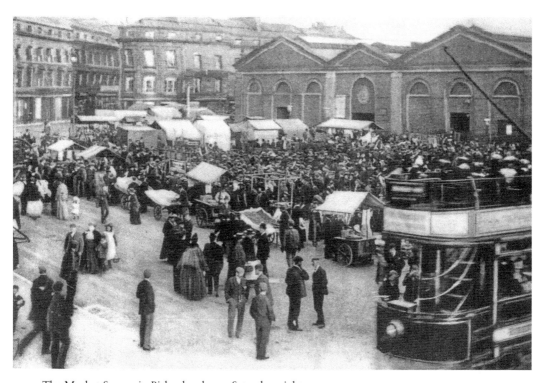

The Market Square in Birkenhead on a Saturday night.

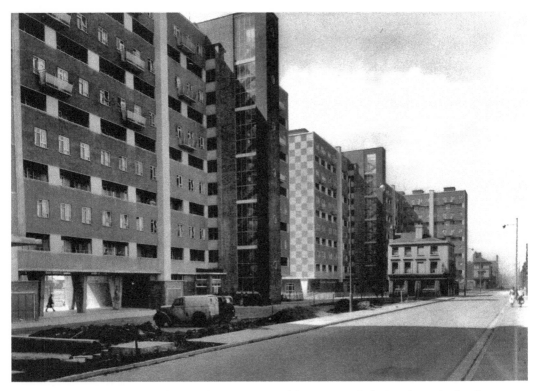

Above and below: Oak and Eldon Gardens were opened by Percy Collick, MP for Birkenhead, on 21 April 1958 as the town's first multi-storey flats. However, they were not popular with residents and were finally demolished by explosion on 30 September 1979.

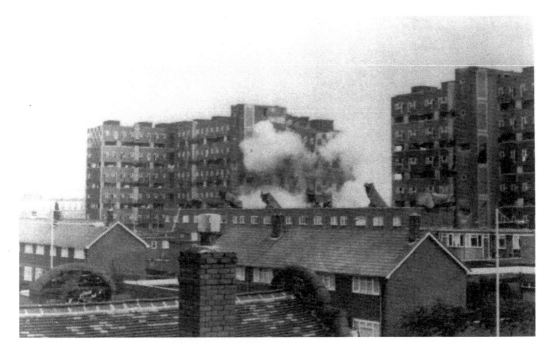

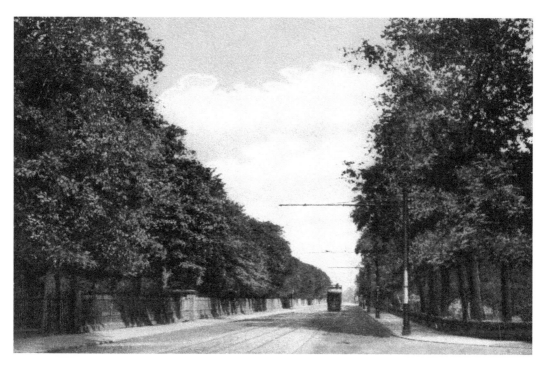

A solitary tram drives down Park Road South on the outskirts of Birkenhead Park.

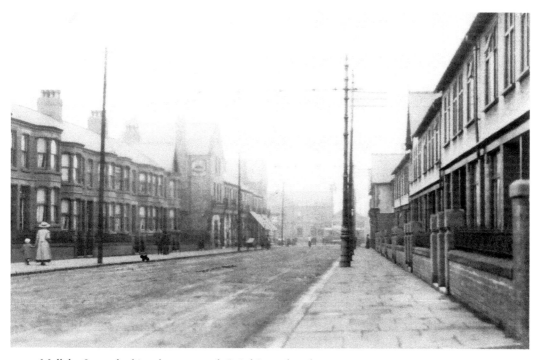

Mallaby Street, looking down towards Laird Street bus depot.

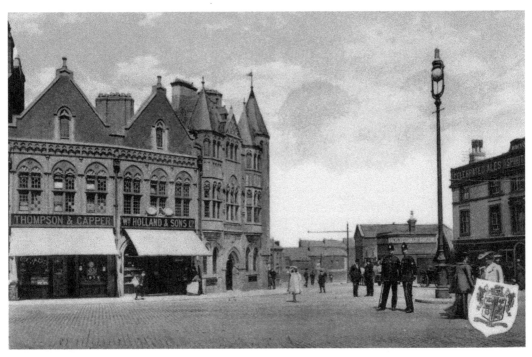

Charing Cross in 1907. The building in the centre of the picture at Charing Cross was originally a branch of the Bank of Liverpool. It was built on the site of the Unitarian chapel.

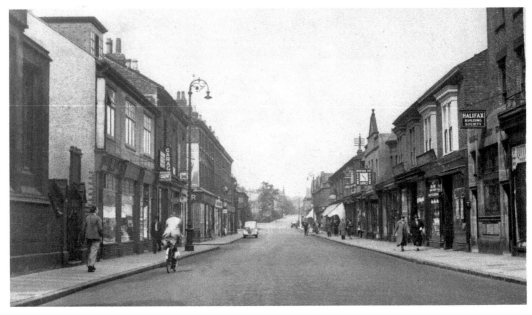

Grange Road West from Charing Cross. To the left of the picture is the Little Theatre, which provides a variety of different entertainments. The Carlton Players were formed in 1930; Birkenhead Dramatic Society began in 1906 and was managed by Harold Smith. The Birkenhead Operatic Society was founded in 1938 to entertain the troops, and in 1949 their first major production at the theatre was Rose Marie.

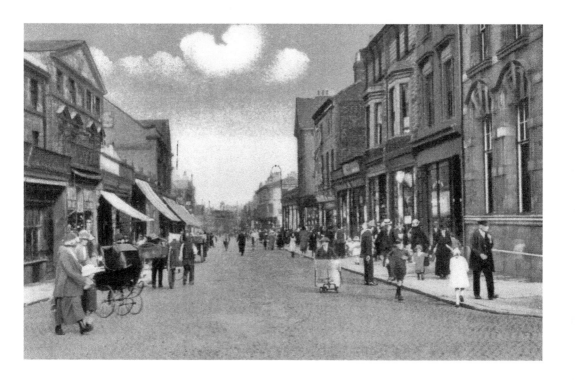

Looking down Grange Road from
Charing Cross.

Advert for Ryalls & Jones, who were located
at 251 Grange Road, Birkenhead.

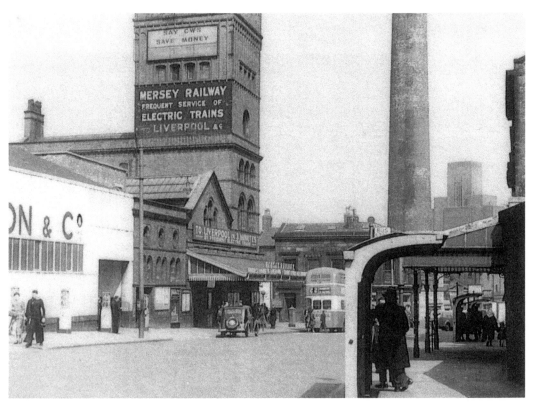

Hamilton Square Station in the early 1960s.

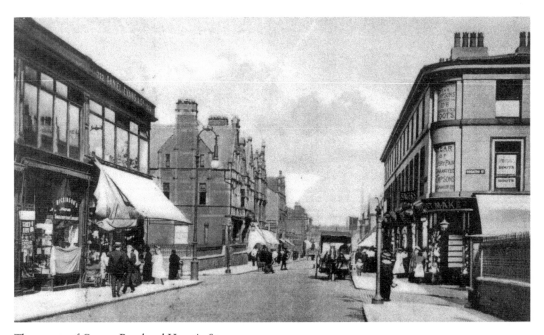

The corner of Grange Road and Horatio Street.

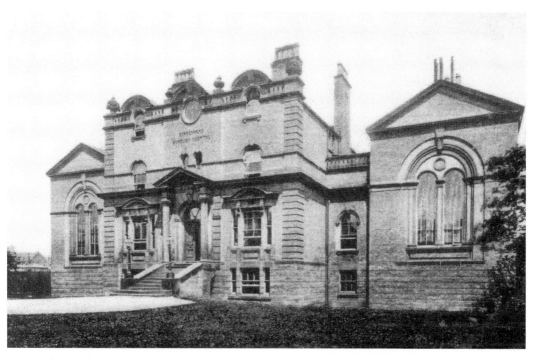

Birkenhead Borough Hospital was built in 1863 with accommodation for fifty beds. It became Birkenhead General Hospital in 1926 and closed in 1982 when Arrowe Park Hospital opened.

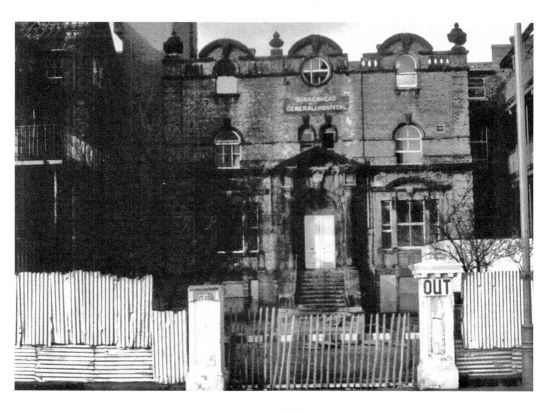

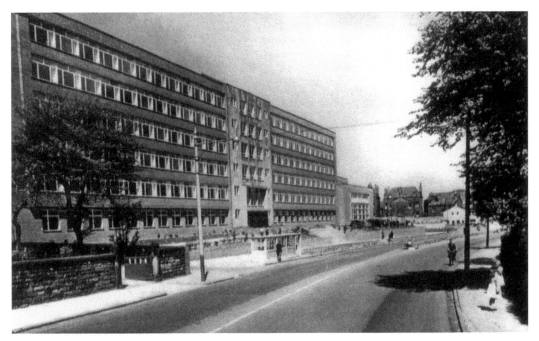

The foundation stone for Birkenhead Technical College in Borough Road was laid by Her Majesty Queen Elizabeth The Queen Mother on 3 May 1950, the day she came to the town to launch HMS *Ark Royal*. It was demolished in 2005 and replaced with a housing development.

Borough Road, Birkenhead.

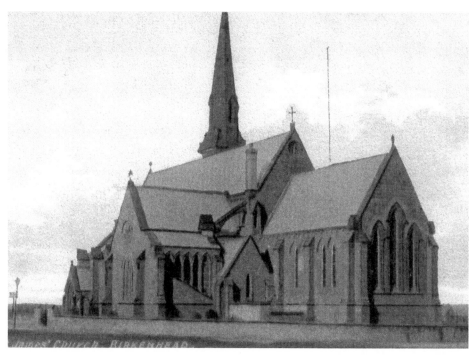

Above and below: St James' church was built in 1858, at the junction of Laird Street and Hoylake Road. It was built to serve the Dock Cottages shown below. The cottages were built by the Birkenhead Dock Company in 1845 to house the families of their workmen. Each block was four storeys high, and each flat was provided with fresh water. The cottages were originally named Queens Buildings and survived for a century before they were demolished and Ilchester Square was built on the site. The final section of Ilchester Square was demolished in 2009.

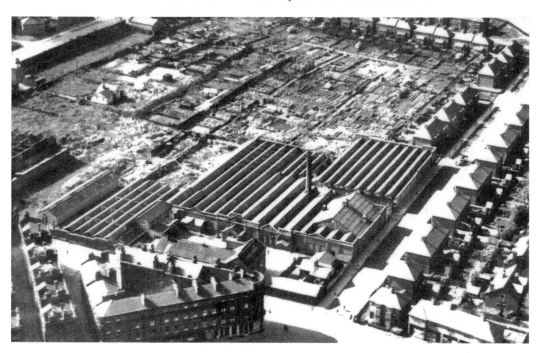

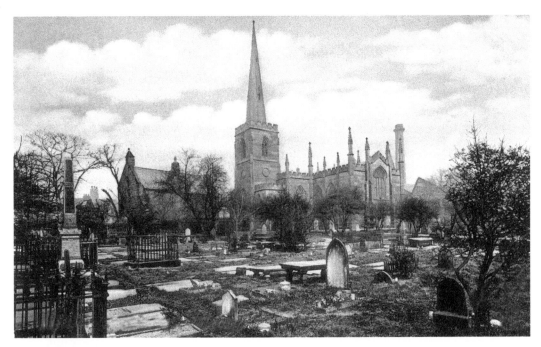

St Mary's church was built by Francis Price on land next to Birkenhead Priory. It was consecrated on 17 December 1821, transepts were added between 1832 and 1835 and further work was carried out in 1883. The demolition of residential properties around the church caused the congregation to move to other areas of the town, and it was decided to demolish the building in 1977. The spire of the church is still intact and services were held in the chapter house of the priory.

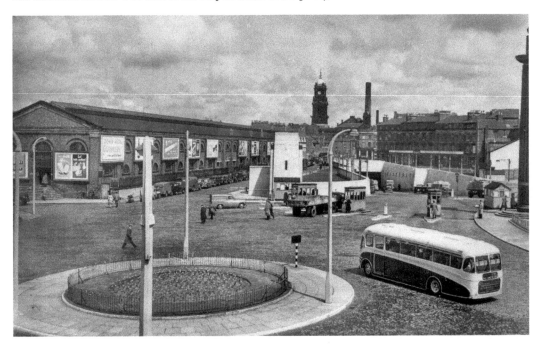

The entrance to the Queensway Tunnel in the 1960s.

Advert for Perrin, Hughes & Company Limited, kitchen, bathroom and fireplace retailer in Conway Street, Birkenhead.

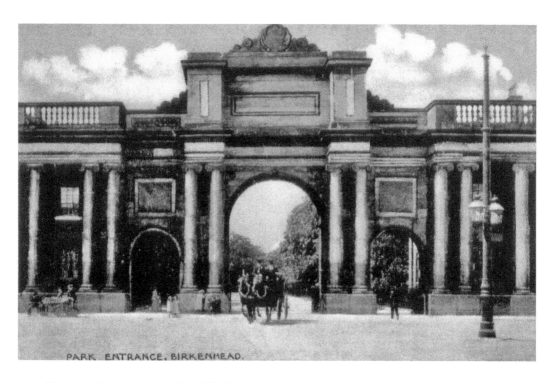

The Park Entrance in Park Road North.

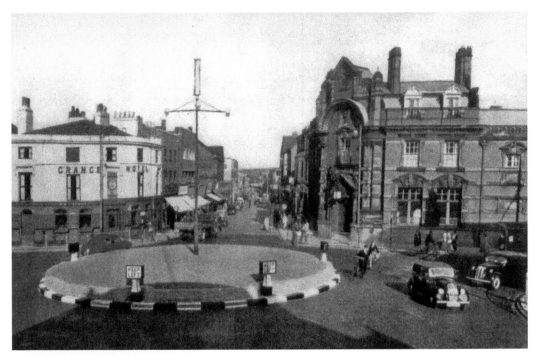

The roundabout at Charing Cross looking down Grange Road.

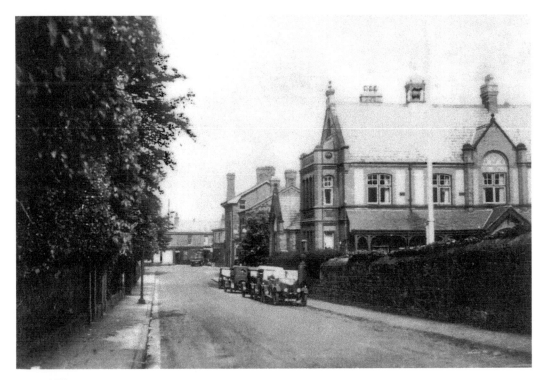

Oxton Village.

Roberts & Company (Birkenhead) Limited were established at the beginning of the twentieth century to deal in metals. The firm developed into merchants for the building trade, providing domestic central heating boilers, cookers, fireplaces, sanitary ware and fittings and plumbers' materials.

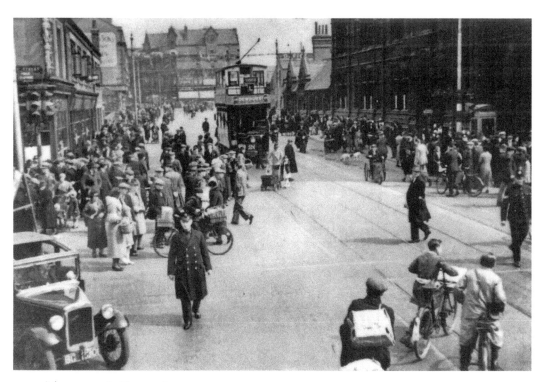

A busy scene in Conway Street.

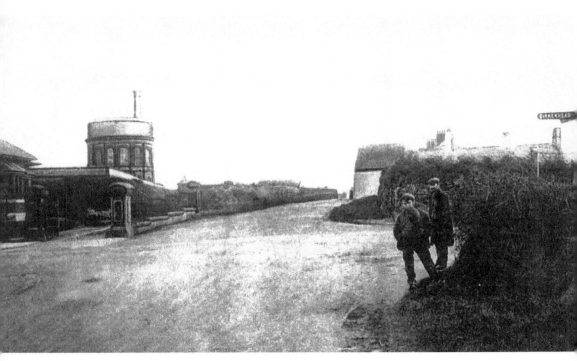

The Flaybrick Reservoir on Bidston Hill.

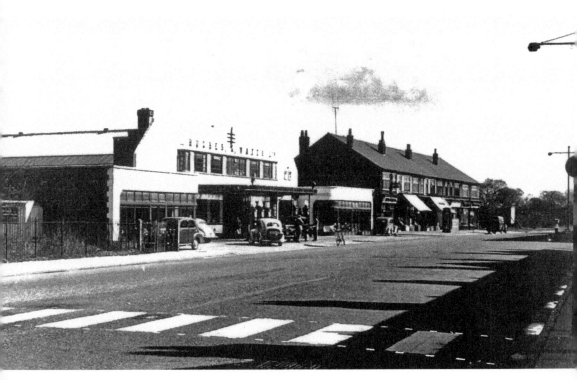

The shopping complex in Woodchurch Road, Prenton, in the 1960s.

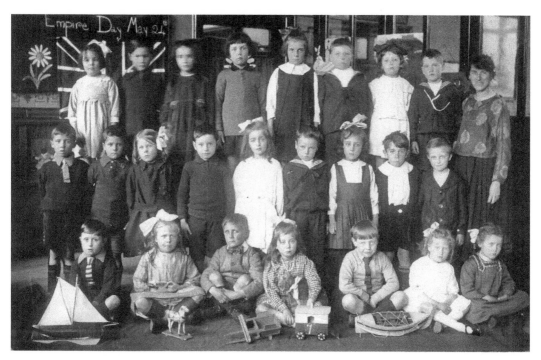

Claughton School, Higher Grade on Empire Day, 24 May.

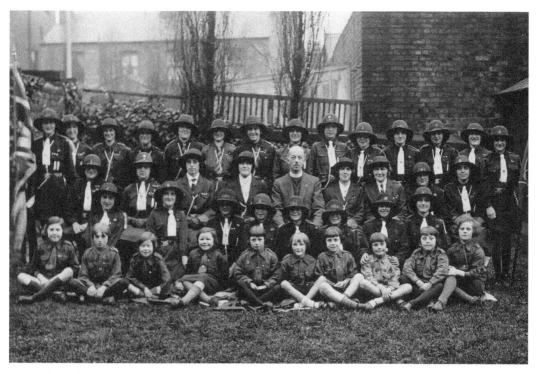

The Girl Guides, photographed by the Birkenhead photographer H. C. Clarkson of Charing Cross.

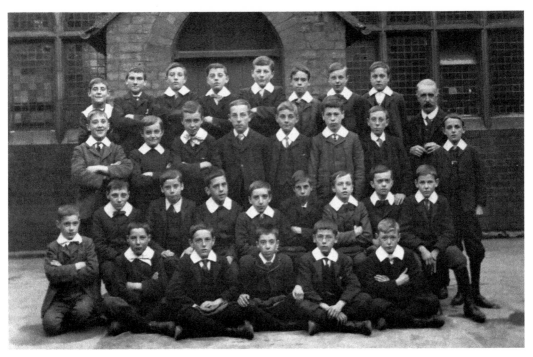

Claughton Street Grammar School, Standard VI in 1907.

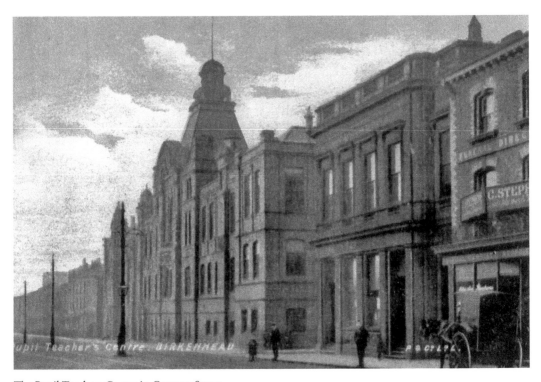

The Pupil Teachers Centre in Conway Street.

Advert for the Royal Rock Hotel in Bedford Road, Rock Ferry.

Upton Road, leading to Upton Village.

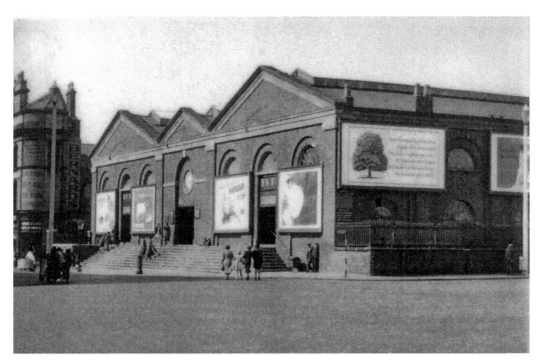

The Market Hall in Birkenhead.

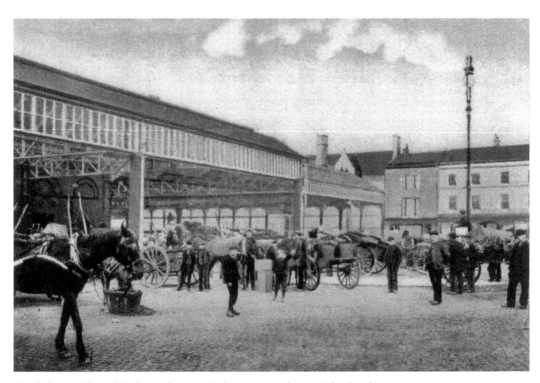

Goods being delivered by horse-drawn vehicles to the market at Birkenhead.

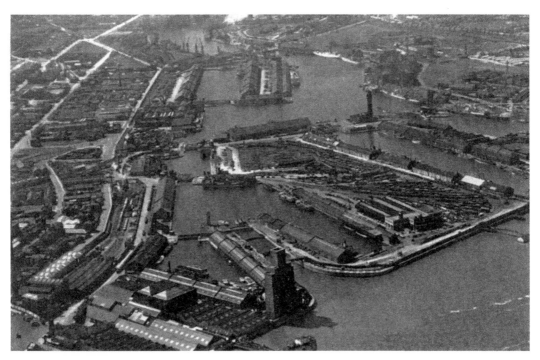

The Birkenhead Dock Estate.

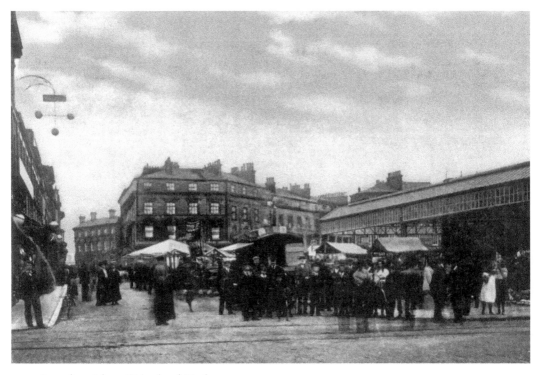

Saturday night at Birkenhead Market.

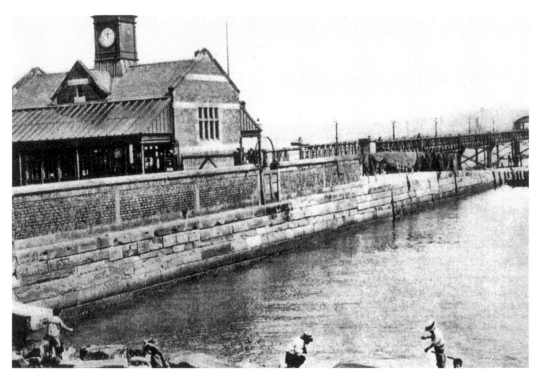

Rock Ferry Terminal and ferry pier.

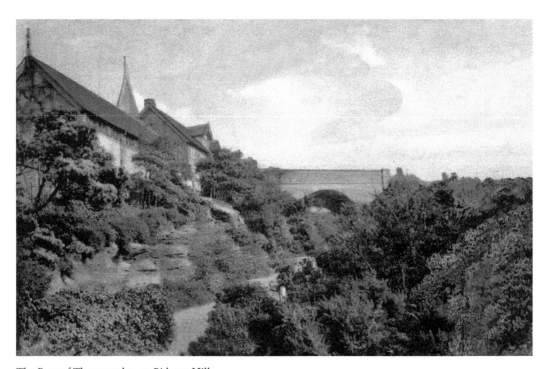

The Pass of Thermopylae on Bidston Hill.

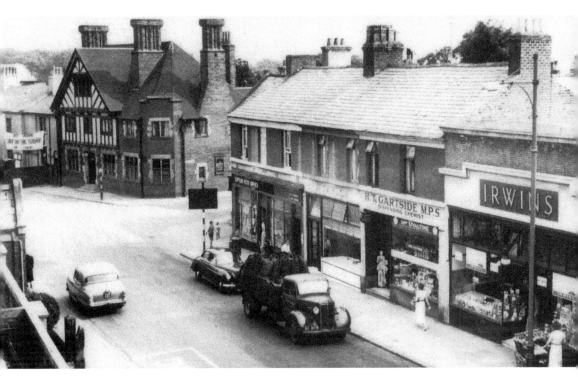

Above and below: Upton Village in the 1950s and 1960s.

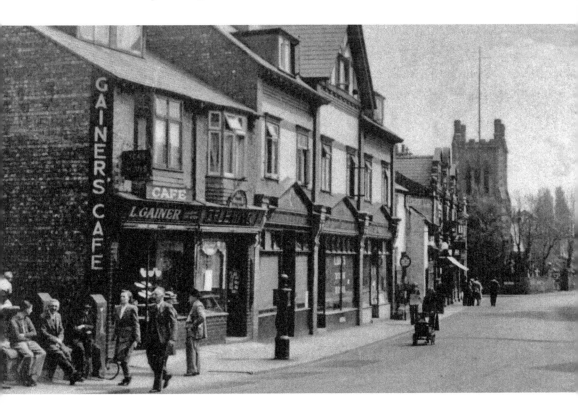

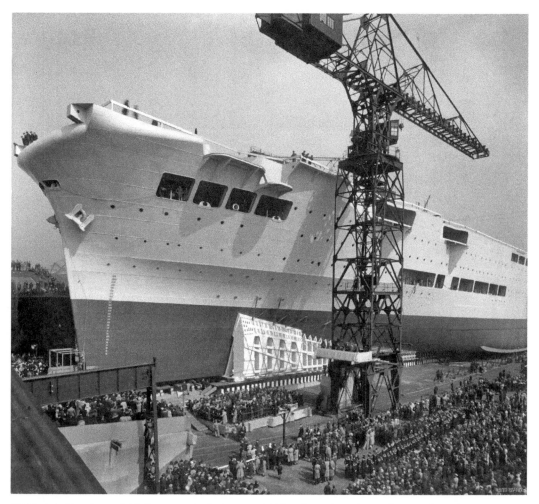

HMS *Ark Royal* was laid down as *Audacious* in 1943, of wartime design but work on her was suspended at the end of the war when the plans were modernised. She became the Royal Navy's first large post-war aircraft carrier and was completed with an angled deck, enlarged island and a new system of electronics. She was launched on 3 May 1950 by Her Majesty Queen Elizabeth The Queen Mother and was finally completed and handed over on 26 February 1955.

She was powered by Parsons geared turbines with eight boilers and four shafts, giving a top speed of 32 knots. *Ark Royal* was refitted between 21 July 1958 and 28 December 1959, when her armaments were reduced and the number of aircraft carried was revised to forty-eight from fifty units. She received her first major refit between 1966 and 1970, when all the guns were removed and she was fitted with the ability to carry four Seacat missiles, but they were never actually installed on her. The number of aircraft carried on her was again reduced to thirty-six units.

Ark Royal was out of service for refitting between July 1973 and April 1974, and October 1976 and May 1977, and she suffered a continual maintenance problem throughout her time in service with the navy. She was the last conventional aircraft carrier operating conventional fighter and attack aircraft and had a stores ship assigned to her to cater for the logistical needs and the aircraft.

It was clear by the early 1970s that the maintenance problems were causing her to be unreliable and a decision to scrap her was made by the middle of that decade. However, as her replacement was cancelled, she was not decommissioned until 4 December 1978 and was finally sold in 1980 to be broken up.

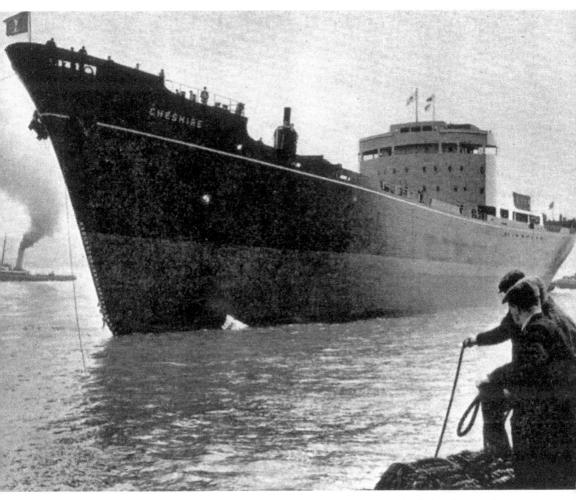

Cheshire was launched at the yard on 23 April 1959 by Lady Bibby, and sailed on her maiden voyage from Birkenhead to Burma on 10 October that year. *Cheshire*, *Shropshire* and *Yorkshire* were three similar sister ships built mainly for the charter trade and spent most of their lives on services other than the core Bibby Line routes.

Cheshire was the third vessel of that name in the history of the Bibby Line and was designed as an open shelter deck type, but with scantlings arranged for deeper draft should the owners decide to close the shelter deck. All accommodation was situated amidships and a complete system of air conditioning was installed. Propelling machinery consisted of a Fairfield Doxford two-stroke cycle, six-cylinder, opposed-piston oil engine developing 8,100 bhp at 120 rpm, and the main engine was designed to operate on heavy fuel.

She was sold to Messageries Maritimes in 1968, and was renamed *Mozambique* for the African and Madagascar service. In April 1970 she assisted in the rescue of crew from the tanker *Silver Cloud*, which had broken in two pieces following an explosion. In September 1974 she was in Mozambique when she assisted in the evacuation of civilians caught in the hostilities during the Civil War.

In 1976, she was renamed *Kota Mewah* following her sale to Pacific International Lines of Singapore and arrived at Kaohsiung on 24 August 1984 to be broken up.

Her sister, *Shropshire*, was sold by the Bibby Line in 1972 to Lefkonia Cia. Naviera S.A., Panama, and renamed *Argiro*, *Naftilos* in 1984 and broken up at Chittagong in 1985. *Yorkshire* was sold in 1971 and renamed *Bordabekoa*, *Sea Reliance* in 1981 and was broken up at Bombay in 1984.

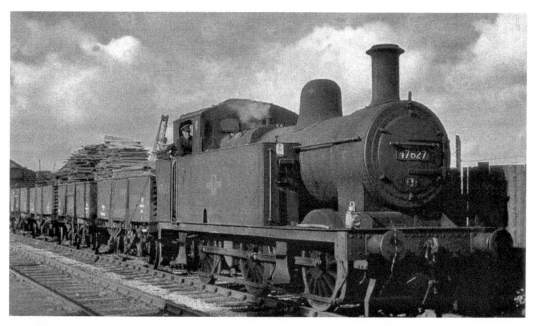

Locomotive no. 47627 takes empty wagons along Beaufort Road towards the West Float.

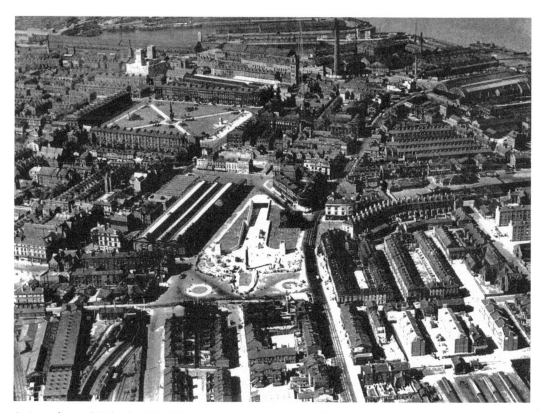

A view of central Birkenhead in 1934, just prior to the opening of the Queensway Tunnel.

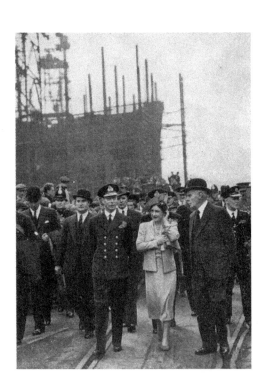

King George VI and Queen Elizabeth visit
Cammell Laird's yard in August 1940.

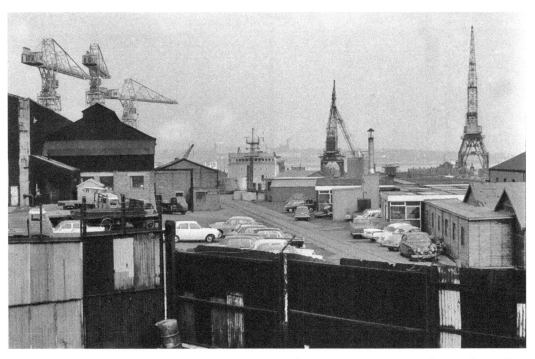

Cammell Laird's shipyard in 1967, showing the Belfast Steamship Company's first car ferry, *Ulster Queen*, in dry dock. She was launched at Birkenhead on 1 December 1966 and sailed on her maiden voyage from Liverpool to Belfast on 6 June the following year.

Acknowledgements

I would like to thank the following for the help and assistance they have given me in the preparation of this book:

Ted Gerry

Larry Clow

Kevin Bennett

Mersey Tunnels

Merseytravel

Cammell Laird & Company Limited

Alison Tennant, PR & Marketing Manager, Peel Land & Property Group